A Landscape Photographer's Guide to
Olympic National Park

Anthony Jones

Right
Angles
Photography

To Lyn, my wife.

These books would be impossible without you.

First edition

ISBN-13: 978-1-7321680-3-9

**MAPS PRINTED IN THIS BOOK ARE FOR ORIENTATION ONLY
AND SHOULD NOT BE USED FOR NAVIGATION.**

Media Sources:

Park Maps, pp. 4-8, 10, 12, 14, National Park Service, public
domain.

Trail Map, p. 44, U.S. Forest Service, public domain.

All other images by the author.

Contents

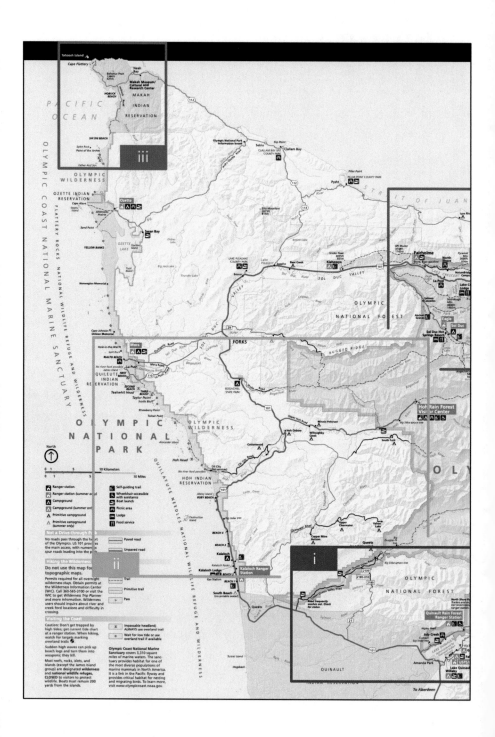

North

0 1 5 10 Kilometers
0 1 5 10 Miles

- Ranger station
- Ranger station (summer only)
- Campground
- Campground (summer only)
- Primitive campground
- Primitive campground (summer only)
- Self-guiding trail
- Wheelchair-accessible with assistance
- Boat launch
- Picnic area
- Lodge
- Food service

Not a Drive-through Park

No roads pass through the heart of the Olympics. US 101 provides the main access, with numerous spur roads leading into the park.

Hiking the Wilderness

Do not use this map for topographic maps.

Permits required for all overnight wilderness stays. Obtain permits at the Wilderness Information Center (WIC). Call 360-565-3100 or visit the WIC to get Wilderness Trip Planner and more information. Wilderness users should inquire about river and creek ford locations and difficulty in crossing.

Visiting the Coast

Caution: Don't get trapped by high tides; get current tide chart at a ranger station. When hiking, watch for targets marking overland trails.

Sudden high waves can pick up beach logs and turn them into weapons; they kill.

Most reefs, rocks, islets, and islands (except the James Island group) are designated wilderness and national wildlife refuges, CLOSED to visitors to protect wildlife. Boats must remain 200 yards from the islands.

Paved road

Unpaved road

Trail

Primitive trail

Pass

Impassable headland; ALWAYS use overland trail

Wait for low tide or use overland trail if available

Olympic Coast National Marine Sanctuary covers 3,310 square miles of marine waters. The sanctuary provides habitat for one of the most diverse populations of marine mammals in North America. It is a link in the Pacific Flyway and provides critical habitat for nesting and migrating birds. To learn more, visit www.olympiccoast.noaa.gov.

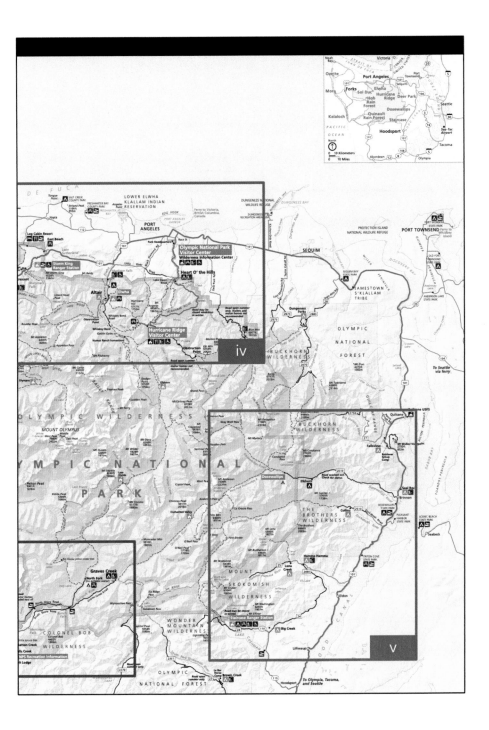

5

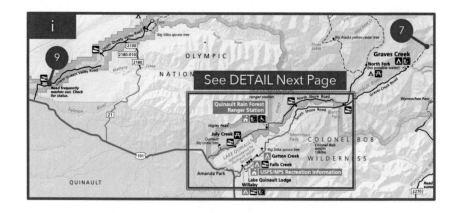

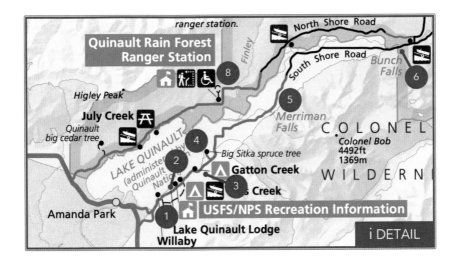

7. Pony Bridge — 52

A semi-lengthy drive and a 5-mile round trip hike does consume time, but the route is pleasant and ends at a splendid little bridge crossing the Quinault River. Elk are commonly sighted along the drive.

8. Kestner Homestead & Maple Glade — 54

First visit a historic homestead dating back to 1891, then follow with a walk through a rain forest and a sea of ferns, finally to a wetland with calm water and its sensational reflections.

9. Queets River View — 57

A unique composition, capturing mountains and rain forest.

Mossy Bench en Route to Maple Glade 28mm f/5.6 1/40s ISO1600

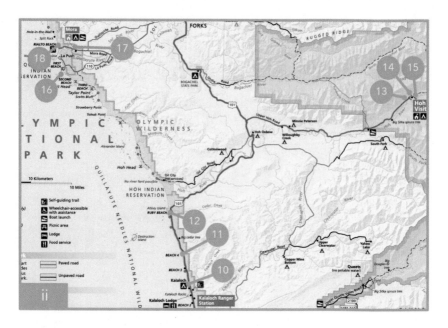

10. Tree of Life 60

*A beachside, wind-battered Sitka Spruce stretches its roots to hover its weight, defying weather and gravity. A **must do** along this stretch of Highway 101.*

11. Beach 4 61

If you're looking for the best, "easily-accessible" tide pools in Olympic National Park, Beach 4 is your destination. With good timing, sunsets are marvelous here too.

12. Ruby Beach 64

Visit the beach and see Abbey Island, the largest sea stack along this coastal section of Highway 101. Abundant driftwood and sensational sunsets add to Ruby Beach's allure.

13. Taft Pond 66

Just before the Hoh Visitor Center lies a body of water that seems to always have something worth photographing.

14. Hall of Mosses 68

*Everyone's favorite rain forest trail, the Hall of Mosses is a "great room" of ferns and towering maples with abundant moss. Most definitely a **must do**.*

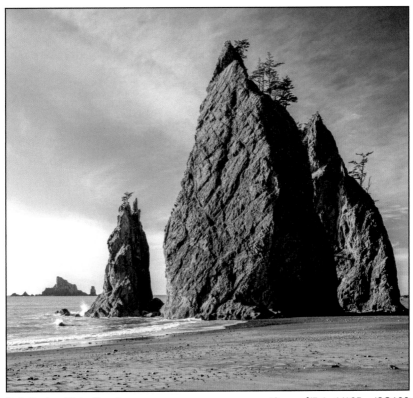

Split Rock at Rialto Beach 40mm f/5.6 1/125s ISO100

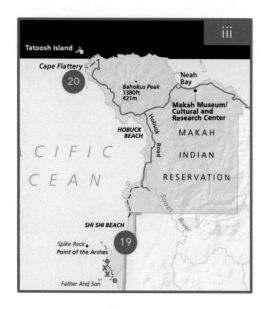

19. Shi Shi Beach 84

Trek 4.5 miles through forest and along Shi Shi Beach to Point of the Arches, a striking cluster of sea stacks reaching out to the ocean. Tide pools can be marvelous here, but due to the hike's length precise timing is required.

20. Cape Flattery 87

While not inside the national park boundary, the trail to Cape Flattery takes you to the most northwest reach of the contiguous United States. The rugged headlands here are absolutely stunning.

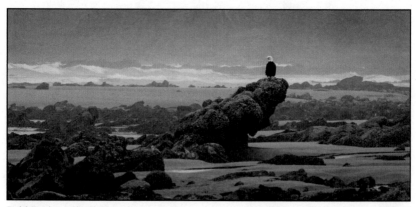

Bald Eagle at Shi Shi Beach 400mm f/5.6 1/640s ISO200

Boardwalk to Cape Flattery 35mm f/8 1/160s ISO800

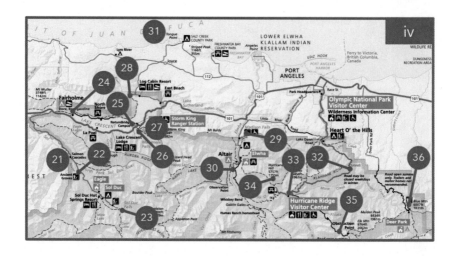

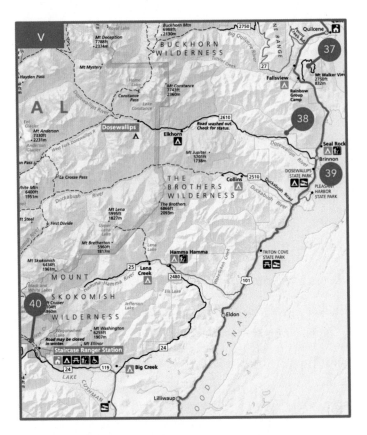

37. Mt. Walker 126

Drive to the top of Mt. Walker and visit two viewpoints – one north, and one south. Seattle, Mount Rainier, and Mount Baker are visible on a clear day!

38. Rocky Brook Falls 127

I couldn't not include my favorite waterfall on the Olympic Peninsula, even if it's not in the national park!

39. Dosewallips Tidal Area 129

This is the very best natural area along the Hood Canal. Capture wild grass, scattered driftwood, shellfish, and birds!

40. Staircase 131

If your itinerary will allow a visit to the Staircase area, make it so. What a remarkable area along the North Fork Skokomish River.

Introduction

Welcome to Olympic National Park, where ocean, rain forests, and mountains meet. Photographic diversity here is in abundance.

The Pacific Ocean can be violent along this very northwest coast, but when the tide recedes it reveals marvelous sea life in protected tide pools. Rain forests transform the abundant, atmospheric moisture and cool conditions to lush gardens on their floors and in their trees. Roosevelt Elk and Bald Eagles are regularly seen. Glaciated peaks of the Olympic Mountains are jagged and photogenic – day and night.

Located on Washington state's Olympic Peninsula, Olympic National Park covers some 1,400 square miles. It is large, to say the least. Navigating it is mostly along its perimeter and requires pre-trip planning to make the most of a visit. Frequently-changing weather, ocean tides, and many off-pavement roads add to the challenge. I will help you plot your course to a memorable and rewarding time here.

This book's purpose:

Its core intent is to guide you **-the photographer-** throughout the park, to minimize "blind exploration" for sites, and to maximize the number of praiseworthy images you take home.

This book is especially catered towards those who I like to call "weekend photographers." Those who may visit the park only for 2-5 days – and for some people what may be their *only* visit to this national park. As such, the sites presented herein are more likely to be roadside or very short hikes, in order to maximize experiences, when time is limited. (There are some longer treks on the list, for those who do have the time.)

My style is also to provide honest information. Not every site is a "must see" / ★★★★. So sometimes the news is great; sometimes not so great. The idea is that you're armed with enough information to create a daily itinerary that meets or exceeds your goals as a landscape photographer on travel. My own philosophy as a traveling photographer, is that I seek destinations where the reward matches or exceeds the effort to get there. This is one of the governing philosophies of this book.

How to Use this Book

I have divided the park, for the photographer's needs, into 5 areas. For quick reference, please see that each area's color is consistent throughout the book. (This is for quickly finding maps, sections, etc.)

While a lot of literature you will come across may speak to the park's history, geology, flora, fauna, and so on, this book will focus mostly entirely on elements useful to the photographer. I'm no historian, geologist, or botanist, and it would be wasteful to reproduce a lot of that information in here, as it would only add to the volume's heft. I sincerely hope that you have room for this book in your camera bag, and that you take it along with you every step of the way.

I've also omitted the most basic "general" photography lessons in here as well. There are many excellent resources on that topic. I will, however, cover some intermediate level topics that I think are relevant to making the most of your photography while at Olympic National Park. The Tips & Techniques section is for exactly this.

So let's dissect the information presented for each of these hikes. The following is a sample, taken from James Pond (17):

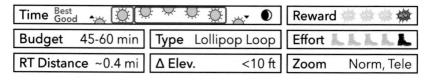

Time: The icons represent sunrise, early AM, late AM, midday, early PM, late PM, sunset, and nighttime. The red box(es) represent the best time(s) of day to be there. The blue box(es) represent good time(s). Ideally you are visiting during the "best" times, but itineraries do not always allow this, hence providing multiple options. The above site is best in the early morning. *One major caveat here: Clouds can change everything (and normally for the better!), offering softer, more accommodating light during other times of the day. Make impromptu adjustments, accordingly.*

Reward: One to 4 "Wow's." Now honestly, if it warrants printing in the book, then it's got merit, right? So a 1-Wow here isn't like a 1-star motel. It's just relative!

Budget: Your time is valuable, and this is how much time you might expect to spend at this site (including getting there, if it is a hike). For the sample site, plan for between 45-60 minutes.

Type: This is the circuit that you will cover. "Roadside" involves some walking (but not hiking); you likely will work *near the side of the road.* "Meandering" means that there's not really a prescribed route, and so you should expect to explore the area via your own path. "Out & Back" is a route that you hike out one way, and then you turn around and hike back on the return. "Loop" begins and ends at the same place, though you mostly will not retrace your own steps. "Lollipop Loop" is an out & back with a loop at the far end.

Effort: This is the physical effort required while on the hike. Here, we are using the "Boots" scale. Zero Boots highlighted is typical for everyday walks, then 1-5 Boots reflect a hike's effort, similar to using the Easy-Moderate-Strenuous scale, but here with a 2-Boot representing Easy-Moderate and a 4-Boot representing Moderate-Strenuous. For the sample site, as you will read about on pages 78-79, the route is easy, hence the 1-boot rating.

RT Distance: "RT" is Round Trip. This is the total hiking distance. Our sample site's round trip distance is approximately ("~") 0.4 mile.

Δ Elev.: Change in Elevation. I need to be careful here. There are many ways to talk elevation and how it is recorded on a hike. For this book and this purpose, what is presented is simply the difference between your lowest elevation and your highest elevation. Some trails go up-and-down, and up-and-down, and so on. This value does not capture the summation of all those ascents and descents; it is merely the difference between the highest and the lowest points, while on the trail. For the sample site, the change in elevation is less than ("<") 10 feet.

Zoom: I'm a firm believer in "less is more." Taking every lens on every hike can be backbreaking. And being weighed-down is no fun. So, in this box I'll suggest the key lens(es) you will want to take. Adding more is up to you. Using 35mm (full frame-equivalent) focal lengths, please consider "Wide" = Wide Angle (15-35mm), "Norm" = Normal (24-100mm), and "Tele" = Telephoto (70-200mm+).

Finally, each section will have photos of *hopefully* what you can expect to see and photograph – or do better than I could! Below most of these pictures are the camera settings that I used for the shot. Example:

Frosty Fall Morning on James Pond 100mm f/8 1/60s ISO200

The Five Park Areas

For your orientation and planning purposes, this book defines 5 geo-graphic areas within the park – South, West, Northwest, North, and East.

Olympic National Park is large, and because so its maps can be deceptive with their diminutive scale. For example, at a glance the Lake Crescent Lodge does not look far away from the Hoh Rain Forest Visitor Center, but it would take 1 hour and 45 minutes to drive between the two. These five sections' boundaries were defined to help primarily with this in mind. Think of your day(s) as efficiently portioned within these areas and across their boundaries. (See also the Driving Information section on page 30 for additional insight.)

I'd like to address the elephant in the room (or the library, perhaps)... **Olympic National Park has *many* more sites with serious photography potential beyond the 40 listed in this book.** Most, if not all, of these are complete day hikes or even overnight. These are not within the scope of this book. I am confident though, if you pursue any of them you will capture many sensational photos, without my guidance.

Exactly *how* to budget your time is the real challenge on the Olympic Peninsula due to the layout of roads and sites (and tides). The national park has three unique geographical features – the Pacific Ocean, three rain forests, and the glaciated Olympic Mountains. Also of interest are dense forests, lakes, wildlife, waterfalls, and historic buildings. On the east side along the Hood Canal is a natural shellfish habitat. There is a lot to see here! My advice is to **prioritize what is of most interest to you.** For a single day visit, concentrate on one area or two adjacent areas. For 2 days, divide your time across two, if not three areas. I would recommend the "entire" peninsula experience for not less a 4 day visit, and this will still be challenging.

Let's take a look at each area...

South

The "hub" of the southern entry into Olympic National Park is Lake Quinault and its vicinity. The Quinault River feeds Lake Quinault from the east and continues its journey from the west end of Lake Quinault to the Pacific Ocean. The majority of our photography sites pepper the two roads along Lake Quinault and the Quinault River – South Shore Road and North Shore Road.

Our first 5 sites along South Shore Road are not actually within Olympic National Park. The area is so great though, I could not have left them off the list of sites to visit! (In fact, *most* of South Shore Road is not within the national park. Bunch Falls [6] marks the park boundary at about 12 miles in from Highway 101.) The Lake Quinault Lodge and the abundant trails in this south shore area are instead managed by the U.S. Forest Service (aka the National Forest Service).

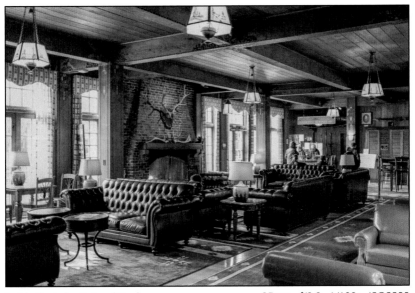

Inside the Lake Quinault Lodge 35mm f/2.8 1/100s ISO3200

By "abundant," I mean there is a real maze of trails here, opposite the lodge, east and west. The map on page 44 illustrates these trails.

South Shore Road is paved for the first 6 miles off of Highway 101 and is gravel thereafter. Its namesake "ends" at an intersection where a bridge crosses the Quinault River, about 1 mile beyond Bunch Falls. If continuing straight, it changes to Graves Creek Road.

The gravel surface condition on Graves Creek Road is... Well, let's say, "it appears *less* frequently maintained." RV's and trailers are not permitted. It is a bumpy and winding road, and at times narrow. The drive is slow, but it is pretty.

Back at Highway 101, now north of the community of Amanda Park, find the large sign stating "Quinault Rain Forest North Shore Rd Loop Drive." The **Quinault Rain Forest Loop Drive** includes North Shore Road (from Highway 101 to the aforementioned bridge), the bridge, and South Shore Road. Unlike South Shore Road, North Shore Road is almost entirely in the national park boundary.

From Highway 101, heading east along North Shore Road, the first of-interest spot not listed as a site is the **July Creek Picnic Area**. There are some *huge* standing and downed trees to navigate here, and the view across the lake of the Lake Quinault Lodge can be picturesque under an accommodating sky.

Further on is the Quinault Rain Forest Ranger Station (aka the Quinault River Ranger Station, per the signage along North Shore Road). This is the pull-in for the Kestner Homestead & Maple Glade (8).

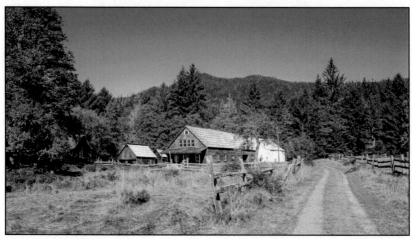

Kestner Homestead 28mm f/8 1/125s ISO100

After another ~2 miles (near the 8-mile marker), the road changes from paved to gravel, and the drive becomes interesting through dense forest. Drive slowly and keep an eye out for wildlife.

Approach a clearing after the 13-mile marker and return to asphalt at **Bunch Field**. This is a favorite place to spot **Elk**. The asphalt treat is short-lived, as you will return to gravel and then come upon the intersection with the bridge and Quinault River at your right and another road (to the North Fork Campground) to your left. Turn right to continue the Quinault Rain Forest Loop Drive. Once over the bridge, turn right onto South Shore Road if the driving loop is your charter, or turn left to the dead end Graves Creek Road.

Beyond the Lake Quinault vicinity, also included in this section is the Queets River View (9). **"What about Queets?"** is a fair question. The third and often forgotten rain forest in Olympic National Park once had its own road thoroughfare, but has since been washed-out. The Sam's River Trail and the Queets River Trail are reported as overgrown. The reward:effort proposition doesn't pan out. Instead, I was able to find a straightforward and unique site to celebrate Queets with the Queets River View.

West

Back on Highway 101 heading north, cross the Queets River and the Pacific Ocean comes to within sight. As large as the peninsula and coast are, the oceanside driving experience is short, consuming only 11 miles along this stretch. (The highway veers inland again after Ruby Beach [12].)

Kalaloch is the name of this vicinity of the park. Take note of the naming convention of these beaches, from south to north, as follows: Beach 1, Beach 2, Kalaloch Lodge (and beach access), Kalaloch Campground (and day use area with accompanying beach access), Beach 3, and Beach 4. *Do not confuse these with First, Second, and Third Beaches further north. (More on these later.)* Beach 2 and Beach 3 are not of interest, relative to their peers, while the Tree of Life (10) at the Kalaloch Campground and Beach 4 (11) are covered. That leaves two to discuss further – Beach 1 and Kalaloch Lodge.

Beach 1 is unique in that it has a short route through the forest known as the **Burl Trail**. Along Highway 101 you will occasionally see these "balls" on Sitka Spruce trunks. This is a convenient place to photograph this phenomenon. A small, brown sign along Highway 101 denotes the Beach 1 access. Parking is on the west side of the road. Budget 15-30 minutes, as the trail is short, and I do not recommend hiking down to Beach 1 – there's not really anything noteworthy to see down there.

20mm f/5.6 1/30s ISO200

Kalaloch Lodge and Cabins is worth pulling into and checking out. Or, if helpful to your itinerary, check out the accommodations – especially in one of the cabins. They are enjoyable to stay in. The wide Kalaloch Creek flows into the ocean just below the lodge. Some nice compositions here are possible, albeit a little challenging because of the thick brush on the hillside. You will need to shoot from as high as possible. A white gazebo is adjacent to stairs with beach access. The beach is wide and sandy here. Compositions of singular rocks on the beach with the distant horizon are simple yet interesting. If in need of food, beverage, or supplies the freestanding store on this property has abundant options, especially given its relative remoteness along this stretch of Highway 101.

Between Beach 4 and Ruby Beach is the **Big Cedar Tree** exhibit, on the east side of the highway. The road is about ¼ mile long and gravel. Unfortunately, the site is a bit underwhelming. The main attraction is a half-fallen, gangly cedar that is difficult at best to photograph and not very good-looking either. Two additional cedars can be visited on a trail behind the half-fallen tree, but time is better spent elsewhere.

Northbound Highway 101 bends inland after Ruby Beach and parallels the Hoh River. The Hoh Rain Forest is *the* rain forest to visit in Olympic National Park. **If you are on a very limited time frame and can only visit one rain forest, I would select the Hoh over Quinault.** Quinault's advantage is its easy access off Highway 101, but the Hoh and its Hall of Mosses (14) is unbeatable for photography.

The only "gotcha" for visiting the Hoh Rain Forest is the lengthy drive in off of Highway 101. Upper Hoh Road is 18 miles long and takes between 35-45 minutes to complete. If coming in prior to sunrise, a bright dawn sky often illuminates the river with a golden hue. Mile markers 4 and 8 have nearby places for good upriver compositions.

Back onto Highway 101, the next area to the north that may be of interest is the city of **Forks**. Forks is a popular "base camp" destination for many travelers visiting the Olympic Peninsula. It is also the setting for the *Twilight* series of vampire-related novels by Stephenie Meyer and its film adaptations. If you were not aware of this, now you will understand why the abundant vampire and *Twilight*-related references, sites, and memorabilia in and around Forks!

On the north end of Forks is State Route 110, aka La Push Road. This is the route to La Push and the Mora district of Olympic National Park. Let's take a look at the map again... Opposite, in order, to the beaches at Kalaloch, see now that we have from south to north Third Beach, Second Beach, and First Beach. *How confusing!*

Third Beach is a noteworthy destination. The hike is longer than that for Second Beach (16), requiring ~1.3 miles to access the beach alone. The novelty of Third Beach is another ~0.6 mile down the beach (south) to **Strawberry Bay Falls** (at right). It is unique – a waterfall that terminates in the ocean. It's issue, and why it didn't earn its own site, is that its flow is low and a bit underwhelming for a ~3.8 mile round trip hike. But, if this is of interest, or if parking is limited at Second Beach, consider it an option. Its trailhead is well-marked along the road.

120mm f/8 1s ISO400

First Beach is accessed in La Push, the community center of the Quileute Tribe. If you choose to pursue Second Beach, I recommend driving into La Push and checking out First Beach. Sizable sea stacks and interesting driftwood make for easy subjects. James Island is the largest and closest sea stack to the beach. Parking is abundant and adjacent to the beach, but traversing down to it can be somewhat challenging for some, as you must walk over and around a lot of *big* driftwood. Be careful with each step.

On the opposite (north) side of the Quillayute River is Mora, which includes James Pond (17) and Rialto Beach (18). Access to this area is via Mora Road. Along Mora Road you will traverse two bridges, one crossing the Sol Duc River and the other crossing the Dickey River. On calm mornings these bridges offer pleasant compositions.

Northwest

Access to the northwest part of the Olympic Peninsula is by way of State Route 112, through the communities of Clallam Bay and Sekiu.

West of Sekiu there is a noteworthy intersection with Hoko Ozette Road, aka Ozette Lake Road. This road ultimately leads to the Ozette district of Olympic National Park, serving the popular **Ozette Triangle** array of trails. I chose not to include the Ozette Triangle as a site due to its remoteness and hiking duration, relative to photography potential. It is beautiful, and without question photogenic. Sea life can be spotted along this coast. If of interest, please research further online.

Back on westbound State Route 112, you will experience a narrow, winding road alongside the Straight of Juan de Fuca. Arrive in Neah Bay, the community center of the Makah Tribe.

In order to access Shi Shi Beach (19) and Cape Flattery (20), a Makah Recreation Permit is required. Permits are available at many locations in Neah Bay. For additional details, please visit **www.makah.com**.

Upon entry into Neah Bay, find on your left the **Makah Cultural and Research Center Museum**. This is a remarkable facility with engaging and informative exhibits. I highly recommend a visit. At time of writing, they are open 7 days a week, from 10am-5pm. For up-to-date information, visit **www.makahmuseum.com**.

Lastly, when driving to the Shi Shi Beach and Cape Flattery trailheads, you will find that the roads and intersections around this area are in abundance. So far, I have relied upon cellular connectivity for driving directions, or at the least a digital map. There are signs along the way helping to point the way around, but in my experience the guidance especially to the Shi Shi Beach parking area lacks clarity.

North

Continuing our clockwise journey around the peninsula, we pick back up on Highway 101 eastbound. The first turnoff of interest is onto Sol Duc Hot Springs Road. Almost immediately find on your right a sign that says, "Welcome to Soleduck Valley." *What?* A pull-in is in front of the sign that leads you to a large set of information boards. I will leave it as a bit of a scavenger hunt to find the board explaining the difference between "Sol Duc" and "Soleduck."

I adore Sol Duc. The three sites I've listed are some of my favorites in the book. Add a stay at the **Sol Duc Hot Springs Resort**, and you will have an entirely memorable experience. The resort has four, concrete-encased, hot spring-fed pools. Three are shaped like hot tubs; one is like a large swimming pool. The three smaller ones are hot, typically between 95-105°F. The swimming pool is cooler. Access is available on a first come, first served basis, with priority given to guests of the resort. To say it differently, you must not need to stay at the resort to access the pools, but due to headcount it will be limited. Inquire by phone for more information at (360) 327-3583. The resort is open seasonally, usually late March through late October.

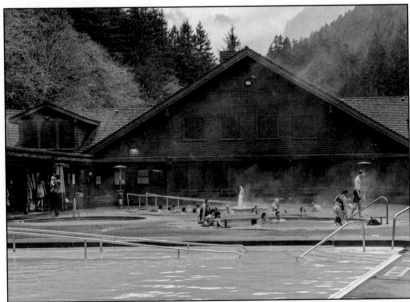

Rainy Autumn Day at the Sol Duc Hot Springs Resort 28mm f/4 1/60s ISO400

Back on Highway 101, Fairholme (24) and Lake Crescent are next. Fairholme is the district along the west end of Lake Crescent... I address its features on pages 96-97. Its turnoff is obvious, though only minimally-marked, onto Camp David Jr. Road.

Begin to take in the magnificence of Lake Crescent. The drive along the lakeshore on Highway 101 is remarkable. If looking for a divine spot for a picnic lunch away from crowds, check out the La Poel Picnic Area, about 2.5 miles from the west end of the lake.

At the east end of Lake Crescent find East Beach Road. If in search for **sunrise** compositions, after about 2.1 miles on East Beach Road are some large rocks near the lake's edge. Another set of rocks are about ¼ mile further down. The rocks provide a clearing for access and potentially a foreground subject (or silhouette). Here is the scene one November morning, sans rocks:

Lake Crescent from East Beach Road 80mm f/5.6 1/160s ISO200

Continuing east again on Highway 101, the next turnoff is onto Olympic Hot Springs Road, which parallels the Elwha River. At time of writing, the Olympic Hot Springs Road is closed to vehicle traffic just beyond the parking area for Madison Falls (29). Two floods, one in 2015 and another in 2017, destroyed the road about 0.8 mile upriver. It's closure is indefinite. Access to trails beyond the washout is possible via hiking or cycling. Consider cycling to the Glines Canyon Dam Overlook (30).

The city of **Port Angeles** is our next stop on this west-east tour and home to the Olympic National Park Headquarters and Visitor Center. Port Angeles, or "P-A" as locals call it, is the largest city on the Olympic Peninsula with many lodging and dining options. If in search of a unique photography option to capture Port Angeles, make the drive out along the Ediz Hook to Harborview Park for a *boat's* eye view of the city below rolling foothills and towering mountains to its south.

Hurricane Ridge Road begins at a split in the road just south of the visitor center... This is an enjoyable, paved drive to the top. The National Park Service works to keep it open year-round, though typically only on Friday-Sunday in the winter for accessing the Hurricane Ridge Ski and Snowboarding Area. Always check the Olympic National Park website for road conditions and status (see page 28).

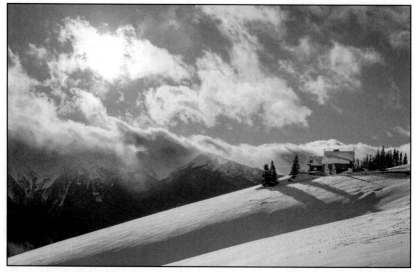

Winter at Hurricane Ridge 50mm f/8 1/1000s ISO100

On the way to Hurricane Ridge you will pass the **Heart O' the Hills** Campground with its advertised Heart O' the Forest Interpretive Trail. I have hiked this trail and did not find it to be particularly photogenic. I recommend skipping, unless perhaps you're camping there.

East of the heart of Port Angeles is Deer Park Road, your means of accessing Blue Mountain (36). I'll save the precious space here and address the rambunctious drive to the top in that site's narrative.

East

Access to Olympic National Park on its east side is a bit limited. I have included one official site, Staircase (40), and this is one fine way to conclude our 40 sites. **Staircase is awesome.** But I've jumped ahead a bit... What about the *rest* of the east?

I chose to include three non-national park stops along this stretch of Highway 101 because, well, if you're in this area they're all great sites for photography. These include Mt. Walker (37), Rocky Brook Falls (38), and the Dosewallips Tidal Area (39). The variety of these, when in addition to Staircase, makes for a pleasant day along the Hood Canal.

One honorable mention in this area is the trail serving Lena Lake and Upper Lena Lake. The latter is within the national park boundary. The round trip distance approaches 13 miles over a whopping 4,000+ feet of elevation gain. It is a popular summer day hike. The road to access it is near the community of Eldon. Consult other resources if of interest.

Services along the Hood Canal are sparse. **Hoodsport**, serving the turnoff for Lake Cushman and Staircase, offers the most options in one place, including a grocery store.

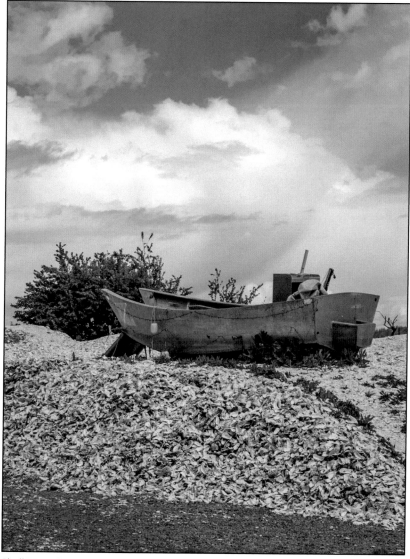

Shell Mounds at the Hama Hama Oyster Saloon 50mm f/5.6 1/800s ISO100

Tips & Techniques

As briefly mentioned in the "How to Use this Book" section, I want to share with you what I think are some of the more unique pieces of advice for your trip to Olympic National Park. Some of this information is park-specific (logistics and planning, mostly), while other information is photography-related (i.e. techno-talk).

Let's get straight to it...

Additional Resources
Please do not skip this!

My goal, in writing this book, is to minimize the resources that you must seek-out, purchase or print, and ultimately rely on in order to enjoy *photography* at Olympic National Park. So, along with the purchase of this book you need access to three additional resources:

1. The Olympic National Park Website (www.nps.gov/olym/index.htm),

2. A printed copy of the National Park Service map of Olympic National Park, and

3. Printed copies of the main park areas' trails (which are in more detail than the main park map).

The Website...

I'm not going to guide you through the whole website – that would be silly. Though, it is in your best interest to make some time and explore it completely, or very close to. Also, a disclaimer – some of these subcategories listed here may change names over time, as the website evolves, so if you cannot find what you're looking for based on my guidance here, try finding it outside the website with your favorite search engine. Just be sure that when you follow the results, you're staying within the www.nps.gov domain. It is the most reliable.

Alerts

On the top banner there is a link to park alerts. This could be abnormal weather or road conditions, or any upcoming or emergency activities that visitors need to be aware of. Check this ahead of your trip, and as connectivity allows, check it regularly during your trip.

Weather

A direct link is available on the homepage. Weather conditions can change very rapidly throughout this region. Again, as connectivity allows, check this regularly during your trip.

Maps

Again on the top banner, follow the maps link for an abundance of great information. Your first mission is to find and download the PDF of the park map that you will be provided once you arrive at a park entrance pay station. These maps are worth their weight in gold. I advise to print in color your downloaded copy on the largest paper possible. The copy you will receive at the park, unfolded, is approximately 24 x 16 inches. This is the same map used on pages 4-14 of this book, and the same map that I listed as Item 2 above for you to carry during your visit.

You're not done printing yet. Unlike the large park maps and the website, the National Park Service has yet to standardize across the parks on how they provide detailed maps and information for trails. At Olympic National Park they are sometimes called "Area Brochures" and other times called "Destination Brochures." (They are one in the same.) Printed versions of these brochures are available throughout the park, most always front and back on letter size paper.

In the same maps link as above (on the website), find a list of these brochures for the various areas. (In this book, since I use "Area" to define a greater region of the park, I refer to these as "Districts." Just FYI.) While the information on the website for these areas is the same as the printed version, the formatting is not set up for efficient printing on letter size paper. Still, I recommend you print some before arriving at the park, so that you at least have something in case hard copies are not available. The following ones could be of use, as they are covered in this book:

1) Deer Park, 2) Elwha, 3) Hoh, 4) Hurricane Ridge,
5) Kalaloch, 6) Lake Crescent, 7) Mora, 8) Quinault Valley,
9) Sol Duc Valley, and 10) Staircase.

There is one more map to note, but this one you don't need to print; it is on page 44. It is of South Shore Road of Lake Quinault, around the Lake Quinault Lodge area. There are a handful of trails here, and I have listed the pertinent ones on pages 38-47. This area is outside the boundary of the national park and is instead managed by the National Forest Service. (South Shore Road is mostly covered by the National Forest Service, while North Shore Road is mostly covered by the National Park Service.)

Driving Information

When studying these maps, the driving distances do not seem that long, and therefore may surprise you. Here are some typical distances and driving times, where VC = Visitor Center:

Lake Quinault Lodge to Forks, WA	67 mi	1.5 hr
Forks, WA to Hoh Rain Forest VC	31 mi	50 min
Forks, WA to Lake Crescent Lodge	37 mi	50 min
Lake Crescent Lodge to Neah Bay, WA	62 mi	1.5 hr
Lake Crescent Lodge to Port Angeles, WA	21 mi	30 min
Port Angeles, WA to Hurricane Ridge VC	20 mi	45 min
Port Angeles, WA to Quilcene, WA	47 mi	1 hr
Quilcene, WA to Hoodsport, WA	37 mi	50 min

Seasons

Olympic National Park is a 4-season destination, but from mid-fall into late spring some of the higher elevation roads may be closed due to snow or mud. Especially of note are Obstruction Point Road (35), Deer Park Road to Blue Mountain (36), and the road to Mt. Walker (37). The road to Hurricane Ridge (33) is open at times in the winter and covered on page 26. Consult the park website for status.

Spring

Springtime is when the rain forests *really rock*. The vibrant greens will blow your mind. The only "trick" is to arrive after the Bigleaf Maples have leaved. I have had great success in late May, though I could have possibly visited a bit sooner with the same result. So, figure mid-May through mid-June is the best for big greens.

While springtime occasionally has sunny skies, more often it is still overcast, rainy, and cool (if not cold). Snow at higher elevations may be starting to melt, but the aforementioned roads will likely remain closed. Ocean beaches don't care too much about seasonal changes, though tides are not as low as in the summertime. Springtime is a good time to visit any of the ocean sites.

Focus especially on rain forests in the spring. They're awesome.

Summer

Summer is when Olympic National Park receives its most visitors. This will translate to accommodations challenges, so if a summertime trip is planned do make any reservations as early as possible. (The same holds true for campgrounds.)

The wonderful part about summertime on the Olympic Peninsula is comfortable temperatures. But wait! This is relative for some people. For some people (dare I say many), the temperatures will feel quite cool still. I live in the Seattle area, so my perspective may not be the same as others... My point is, when it comes time to pack for your trip, study the forecast around the region closely. *Do not just see what the forecast is for Port Angeles.* The peninsula receives its least rain in the summertime.

For the forests, the best color is in June, and afterwards the "intensity" of vivid greens does begin to fade.

For the mountains, the roads become accessible. Some may not open until July, so check the park website for updates. One of the features of the higher elevations in Olympic National Park are wildflowers. Look for peak bloom mid-July through mid-August. Around Hurricane Ridge (33), explore the meadows adjacent to the large parking lot, Hurricane Hill (34), and especially along Obstruction Point Road (35). Blue Mountain (36) also has wildflowers, but typically not as many as these other spots.

40mm f/6.3 1/250s ISO100

An alternative to wildflowers is the Pacific Rhododendron when it blossoms. See page 125 for a sample. They are found along the Hood Canal, usually in May. Dosewallips State Park (on the west side of Highway 101) has hiking trails near its entrance with Rhododendrons within the forest. Inquire with a Washington State Park Ranger for more information.

For the ocean, not only do the lowest tides occur in the summertime but the days are their longest (sunrise to sunset). This gives visitors the most flexibility for memorable beach visits.

Fall

It comes as no wonder that fall brings fall color, but on the Olympic Peninsula the show is not extravagant. *The peninsula is mostly covered with evergreens.* The deciduous trees of interest are Bigleaf Maple, Red Alder, and Vine Maple. Bigleaf Maple and Red Alder offer color, but it tends to be a mild yellow that somewhat quickly turns to a brown.

The best of the lot is Vine Maple, and it can offer brilliant shades of yellow, orange, and red. Look for Vine Maple growing lower to the ground with smaller leaves. They are scattered all around the peninsula, and they are prevalent in the rain forests. Catching them at the right time for color is, well, hard to predict. The best I can offer is that it usually happens between the second week of September through the end of the month.

Various roads to higher elevations may remain open. Fall visits to beaches are indistinguishable from those in the springtime.

One site of note is Salmon Cascades (21). Fall is when you want to visit to witness the salmon swimming and jumping their way upriver. This typically occurs late September through October.

Winter

Wintertime in Olympic National Park is cold, but arguably "mild" compared to many other states at this latitude. Since access to higher elevations is limited, as previously mentioned, you will be focusing your time in the forests and at the ocean.

Expect abundant rainfall and the occasional snowfall.

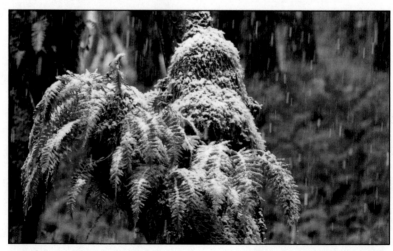

Snowfall in the Quinault Rain Forest 200mm f/4 1/60s ISO1600

Tides & Tide Tables

It goes without saying that as beach explorers we desire low (or at least "lower") tides. Do not count on your own good luck with spontaneity for desirable results – **plan ahead**.

Tide tables are readily available. My favorite, easy-to-use resource is **www.tides.net**. You will select Washington (state), then the pertinent tide station. For sites with beaches where the tide matters, I have listed in a light blue below the usual top table of information the nearest tide station to use. Once having selected the tide station, at the top you can scroll to your month (and year) of interest. I normally print or take a screen shot of this information before I travel.

My general rule of thumb is not to pursue low tides any higher than +2 feet. This is even pushing it a bit for tide pools. Really +1 foot and lower is best. And even lower, the more exceptional they become.

Arrive before low tide to give yourself time for orientation and to allow yourself the opportunity to continue to work outward as the tide ebbs (recedes). **A strong word of caution – always be on the lookout for "sneaker waves." These are waves that can come crashing in and temporarily engulf an exposed tide pool area. Have an exit plan already identified and if you see one coming use it.**

Lastly, I highly recommend wearing durable shoes and gloves while walking on the wet, exposed rocks. These surfaces are slippery; the gloves will help to protect your hands if you need to steady yourself.

Wildlife

Olympic National Park has an abundance of wildlife. Roosevelt Elk and Bald Eagle sightings are the two most often pursued...

Roosevelt Elk

Elk are most abundant in the Quinault Rain Forest, most often east of Lake Quinault. Driving the Quinault Rain Forest Loop Drive (pages 19-20) is your best bet to see them. They are also regularly-seen in the Hoh Rain Forest on area trails, in the campground, and along the northeast end of Taft Pond (13).

Bald Eagles

While throughout Western Washington, Bald Eagles congregate and nest along saltwater and freshwater shores. I have seen the most along Third Beach, Shi Shi Beach (19), and the Dosewallips Tidal Area (39). Regularly check the sky above anywhere in the park – they may be flying above at any time.

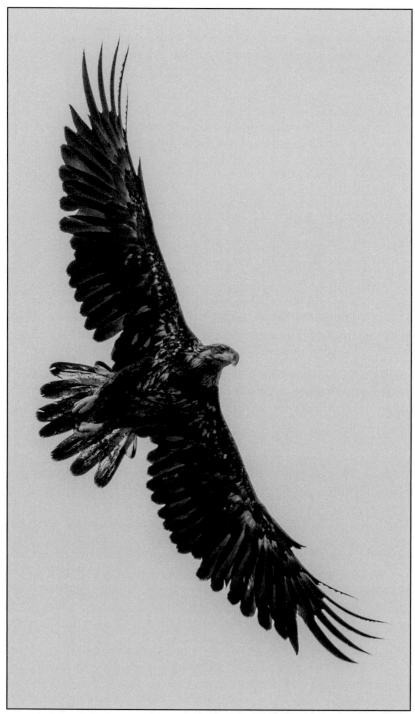

Juvenile Bald Eagle

200mm f/8 1/1250s ISO200

Filters

Polarizing Filter

Do not leave home without your polarizing filter. There are lengthy articles on linear polarizing filters vs. circular polarizing filters – the topic is in my opinion too scientific for this book... If in doubt, use a circular polarizing filter. Most modern cameras will not meter correctly with a linear polarizer. (If you are still curious on this topic, seek further wisdom online.)

Aside from a functioning camera, a polarizing filter is the most important tool in your camera bag. Most are round and are threaded to screw onto your camera lens. Though, not all cameras and camera lenses have threads to accept accessory filters. Adapters are available for nearly every configuration. Once again, check online for availability for such adapters, if necessary.

A circular polarizer has a rotating front element, that when turned (and while you're looking through it – either by itself or through the camera) reduces glare and reflection of light. It also tends to enrich colors. And while colors' "pop" may be simulated using saturation and hue adjustments during post-processing, I have yet to find a computer program to date that can easily simulate a polarizer's effect on water. This is where it really shines. On a water scene, look to the polarizing filter to reduce glare, to see "into" the water, and sometimes enhance the reflections on the water's surface that you do want. **These are a must have for tide pools.**

One caveat to polarizing filters... They really only work when the light source (the sun) is at a substantial angle, relative to the lens. At sunrise and sunset, you will not experience its effects. During very early morning and late afternoon, its effect will be minimal. Mid-morning through mid-afternoon, they work best. No need to memorize all this! Experiment, and enjoy learning its behavior.

Neutral Density Filter

A neutral density (ND) filter is like a pair of sunglasses for your lens. Its purpose is to filter light, so that you can apply longer shutter speeds. This is the "density" part of its name. The "neutral" piece implies that its use won't impact the color tone of your photograph, but in reality they all do somewhat. And typically, the darker they are, the more un-neutral they become.

Like circular polarizers, the most typical format are those that screw onto the front of the lens. They come in an abundance of varieties, but if you are just starting out, my recommendation is to select either a 3-stop (0.9) or a 4-stop (1.2) neutral density filter.

Why use a ND filter? For the landscape photographer the most common application is for use with waterfalls. If your desire is to create that silky-looking flow of water, you need to really slow your shutter speed down. Take a look at the shutter speeds used on waterfalls throughout this book. For the look I'm describing, you generally need to be 0.2 second or longer. My rule of thumb is 0.5 to 2 seconds. Any more isn't doing as much for the look of the water, but perhaps the rest of your scene benefits otherwise. Conversely, if your goal is to capture the more natural "tumble" of water, try between 1/60-1/100 second.

Beyond waterfalls, the use of a ND filter can yield interesting results at the beach. The following was taken with a 10-stop ND filter near Hole-in-the-Wall at Rialto Beach (18), while waiting for the tide to recede further:

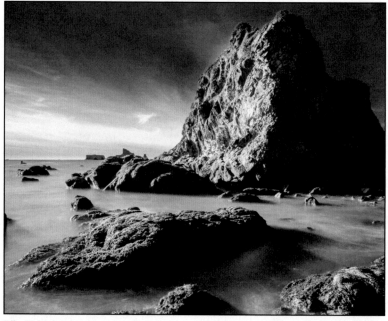

Silky Tidewater 24mm f/16 30s ISO50

Capture vs. Final

When capturing an image, I pay close attention to its histogram, and I encourage you to as well. (Go research this topic if necessary.) None of the photographs in this book are "straight from the camera." But then again, none have what some might call "voodoo" applied either. Just basic adjustments to shadows, highlights, saturation, contrast, etc. – to mimic, as best I can, what I remember seeing.

South

Quinault to Queets

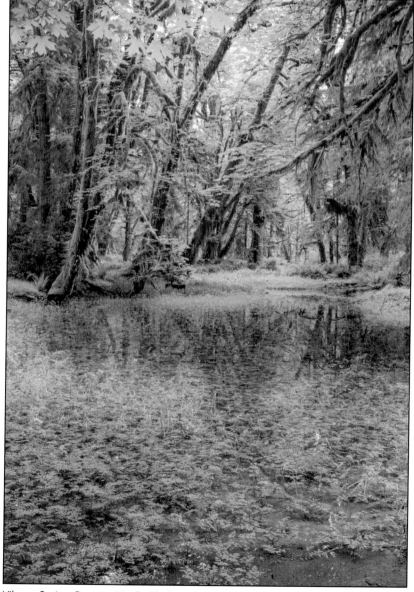

Vibrant Spring Green at Maple Glade 28mm f/16 2s ISO100

Time Best/Good		Reward			
Budget	1.5-2 hr	Type	Loop	Effort	
RT Distance	~0.9 mi	Δ Elev.	~90 ft	Zoom	Norm, Tele

The Rain Forest Nature Trail (and the adjacent **Willaby Falls**, also covered in this narrative) is a worthwhile stop in this area. Based on congestion, I believe it's also the most visited site along South Shore Road, accompanied closely by the Lake Quinault Lodge (2).

Admittedly, the photography opportunities are good, but not great, along this short hike. Were it not for the abundant and world class information boards along the trail, I probably would have scored it less. But I mean it – these information boards are the best I've seen anywhere, and they do a truly remarkable job of orienting visitors to this diverse, temperate rain forest environment.

Approximately 1.0 mile off of Highway 101 (whichever of the two roads you enter on) is the well-marked entrance and parking lot serving the trail. The trailhead location is also obvious, next to a large reader board with one very interesting painted, wooden map of the route.

Once in front of this wooden map, take note of the yellow-colored Quinault Loop Trail junction near the bottom left. This will be your route, not long after the hike begins, to Willaby Falls. More on this in a moment...

Begin the trail, veering to your left, to hike the Rain Forest Nature Trail clockwise. In short time reach a large Douglas Fir with a platform encircling it. Even with the surrounding platform, its size is challenging to capture in camera. The easiest means is to have a person within the frame, illustrating the magnificence of its trunk.

Continuing on, soon reach the intersection to the Quinault Loop Trail, here sometimes marked as "Lakeshore Trail." This is the route to Willaby Falls, and I recommend to visit. While to this point you have not gained much elevation (~10 ft), you will descend significantly and quickly, under South Shore Road, to the falls. This is the most technical part of the hike because the path in places is eroded. It is passable; just take your time and if wet expect surfaces to be slippery.

Willaby Falls is one of those stops where it's delightful to visit and see, but it can be difficult to compose an unobstructed view of the falls. (This is the case in many places throughout this park because the flora is just so thick!)

A shot from the bridge allows for an interesting composition of the

flowing water just below you, thanks to some interesting, in-line boulders. From the bridge though, the waterfall drop upstream is entirely out of sight. Move off the bridge and to the right at a well-worn and obvious place just off the trail. This is the spot to photograph the falls, even though some obstructions remain present. I like telephoto work here, to hone in on the flowing water and adjacent moss- and fern-covered rocks. Below I captured a Pacific Wren taking a break from her day's work. A hint: if there is some brush near you in the way, try opening your aperture so as to help "blur" it out of the picture. This is what I did below, and the nearby twigs in the frame are imperceivable. Once finished, head back up to the main loop trail.

Pacific Wren at Willaby Falls 300mm f/5.6 0.6s ISO100

The trail follows close to the edge of a gorge, thanks to a fence and handrail at your left. Some interesting photos of the creek below are possible.

The handrail soon ends. Begin to climb into the forest. After ~300 ft or so you will see off to your right this interesting nurse stump, felled a century ago. I believe it is a Douglas Fir, as Western Red Cedars tend to be more shapely near the ground. The now-thriving, live tree is a Hemlock. Notice the notch, where the logger's springboard would have been cantilevered from, to stand on.

Nurse Stump 24mm f/4 1/20s ISO800

Moving on, soon reach the intersection for the Quinault Loop Trail. Turn right to remain on the Rain Forest Nature Trail.

Zigzag through some large, fallen trees from a very windy fall/winter 2020/2021. A "Winds of Change" information board highlights this semi-regular activity and its contribution to the rain forest environment.

The remainder of the hike meanders through the dense forest, gently loosing elevation most of the way back towards the start. Be on the lookout for quintessential "rain forest" compositions along the way!

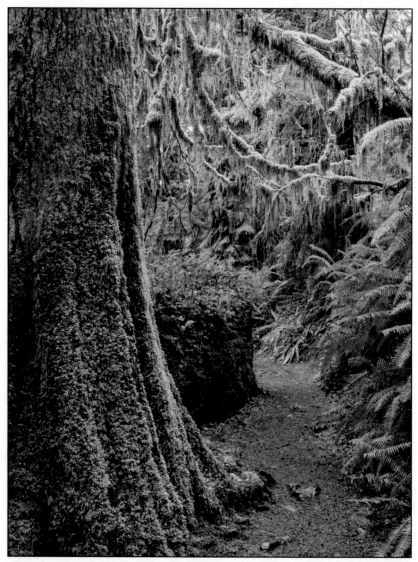

Along the Quinault Rain Forest Nature Trail 50mm f/16 6s ISO400

Time Best Good	☀ ☀ ☀ ☀ ☀ ●	Reward ✹ ✹ ✹ 💥
Budget 15-45 min	**Type** Meandering	**Effort** 🪓 🪓 🪓 🪓 🪓
RT Distance <0.2 mi	**Δ Elev.** <30 ft	**Zoom** Wide Angle

Built in 1926 and managed by the National Forest Service today, the Lake Quinault Lodge is not to be skipped if in the area. While I may not be overly generous with its "Wow" factor, perhaps because it's more *structure* than landscape, it does provide the visiting photographer some variety to the take-home portfolio.

Budget ~15 minutes for a quick, lakeside peek up onto its lawn and large, rustic façade, or allow more time to check out the inside and more of its outside up close.

Not to be missed is an inspection of its colorful annual rainfall gauge, pictured below and center, attached to the exterior of the large chimney. Unlike many rain gauges, this one is measured not in inches but feet!

Just to the main lodge's north end, en route to newer, contemporary rooms, is a small grove of Coast Redwoods. Be sure to check them out.

Inside near the street-side entrance is an abundance of information on the lodge and vicinity. Continue down the adjacent hall to the lodging registration / gift shop for some more colorful stories and details, including a curious Sasquatch exhibit. There's a lot to learn here!

I highly recommend an overnight stay in the lodge, if your itinerary allows. The below photo was taken at nighttime during one of my visits.

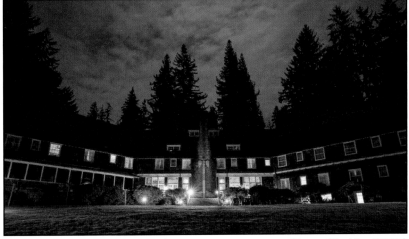

Nighttime at the Lake Quinault Lodge 20mm f/4 10s ISO200

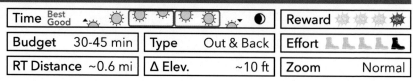

Time	Best Good								Reward				
Budget	30-45 min		**Type**		Out & Back		**Effort**						
RT Distance	~0.6 mi		**Δ Elev.**		~10 ft		**Zoom**			Normal			

Of the waterfalls in and around the Lake Quinault Lodge area, not including Merriman Falls (5) and Bunch Falls (6), this is my favorite. It's more of a long, staircase cascade than a singular waterfall, but when you add the short, but enjoyable hike to it, plus the delightful bridge to photograph from it's an entirely likable experience.

Access is via a trailhead off of the unmarked Wrights Canyon Road. If eastbound from the lodge area, come upon signage to the Gatton Creek Trail... *Do not turn here.* Cross the bridge over Gatton Creek, then immediately turn right onto Wrights Canyon Road. Continue up the road ~0.4 mile and find a well-defined trailhead on the right, adjacent to a small footbridge. Park, and begin the walk (heading out over the footbridge).

Once at Gatton Creek, compose upstream. Here you can work wide, to take in the entire cascade, or you can work with longer focal lengths, honing in on details along (and within) the creek. At times this creek produces a lot of water flow, so logs within it regularly change position.

Off-trail approaches (at the bridge's ends) are not safe. Photograph only from upon the bridge. Finish, and backtrack to your car.

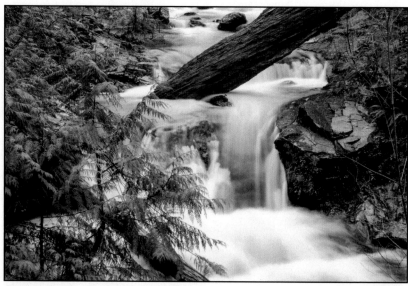

Gentle Cascades of Gatton Creek Falls 70mm f/16 2s ISO50

If you have already studied the Quinault National Recreation Trail System map (on the next page) or happen to be looking at one of the trail map reader boards in the vicinity, you will notice there are very many trail options at your disposal. Two, in particular, could have potentially warranted their own site narratives – the "Falls Creek Loop" and the World's Largest Sitka Spruce... But I didn't. Instead, I will provide a brief insight to these and two other noteworthy ones.

Quinault Loop Trail: This grand combination of trails is not frequently listed, but is in the "vocabulary" of the area. In essence, it is a counterclockwise loop, beginning with one of the two legs of the Rain Forest Nature Trail (I recommend the gorge side), then followed by the segment en route to the **Cedar Bog**. There is one intersection, ahead of the Cedar Bog – stay left towards the bog. *This boardwalk through the abundant cedars is pleasant.* Connect with the Falls Creek Loop and turn right, making your way over Falls Creek (spoken more on below), and then beyond Cascade Falls, finally crossing Falls Creek again... Winding down towards the Quinault Ranger Station and the lakeshore, in front of the Lake Quinault Lodge, finally beyond the lodge (to its west) and continuing sort of along the lakeshore back to Willaby Falls and connecting finally to the Rain Forest Nature Trail on the loop's completion. This is a good family hike and captures some of the best elements of the area, but it can be a bit time-consuming. Figure ~4.0 miles, ~200 feet elevation, and ~2.5 hours.

★**Falls Creek Loop:** OK, I am toeing the line here a bit... I will discuss the formal "loop," but when budgeting time I recommend just the east section of this trail. The formal "Falls Creek Loop" is another counterclockwise route, this time from the Lake Quinault Lodge, uphill towards and over Falls Creek, down to the *over-promoted* Cascade Falls, back again over Falls Creek to South Shore Road. The ~0.6 mile west side of this trail is, frankly, "not awesome" for photographers. Furthermore, **Cascade Falls** is completely shrouded by brush from the trail and is impractical to photograph otherwise. As such, I recommend the east leg of this trail only (an out-and-back), which is clearly marked off South Shore Road on the west side of Falls Creek. If you hike up this section (from the road) you will be rewarded with two tunnel-like passageways through alders covered in moss with a pleasant bridge and rather interesting maple as your destination. (Continue along the trail another ~200 feet for an elevated view of the bridge, maple, and Falls Creek.) If hiking the loop in its entirety, figure ~1.6 miles, ~140 feet elevation, and ~1.5 hours. If hiking the out-and-back I recommend, consider instead ~0.9 mile, ~90 feet elevation, and ~1 hour.

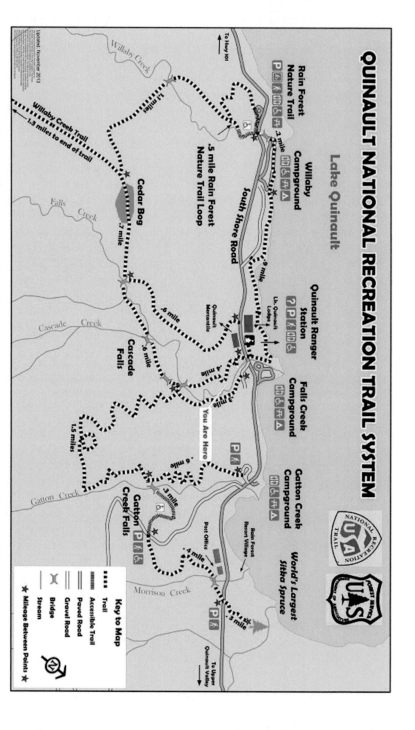

QUINAULT NATIONAL RECREATION TRAIL SYSTEM

Lake Quinault

This trail map is provided courtesy of the U.S. Forest Service. Please disregard the "Your Are Here" note.

Rain Forest
Nature Trail

Willaby
Campground

Willaby Creek Trail
1.3 miles to end of trail

.5 mile Rain Forest
Nature Trail Loop

Cedar Bog
.7 mile

South Shore Road

Quinault Ranger
Station

Falls Creek
Campground

Gatton Creek
Campground

World's Largest
Sitka Spruce

Lk. Quinault
Lodge

Quinault
Mercantile

Cascade
Falls

You Are Here

Gatton
Creek Falls

Post Office

Rain Forest
Resort Village

To Upper
Quinault Valley

Updated: November 2013

To Hwy 101

Willaby Creek

Falls Creek

Cascade Creek

Gatton Creek

Morrison Creek

.6 mile

.9 mile

.4 mile

.6 mile

1.5 miles

.6 mile

.3 mile

.5 mile

Key to Map
Trail
Accessible Trail
Paved Road
Gravel Road
Bridge
Stream
Mileage Between Points

NATIONAL RECREATION TRAIL

FOREST SERVICE

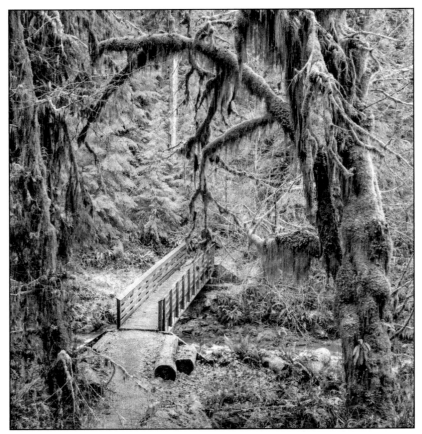

Falls Creek, Bridge, and Maple 50mm f/4 1/25s ISO800

Fungi is in abundance in this area, and I have found *especially* along this east side of the Falls Creek Loop. Keep your eye out!

Falls Creek Falls: Falls Creek passes under South Shore Road and just after its journey below an almost non-descript bridge it cascades over two somewhat-interesting falls. Just west of the creek's passage along the road is a pull-in parking area on the north side of the road. From this parking area is a trail with a gentle descent, switching-back once towards the creek. A viewing area and bench are available, but the perspective is lackluster. From this vantage only the larger, gushing waterfall on the left is visible. The more interesting, gentle fall on the right is not. To access the opposite creekside for the desirable view, follow the path to a footbridge over the creek. This places you inside the Falls Creek Campground. Now the problem is that to access the creekside area you want, you have to walk *through* campsite 20. Whoops! If no one is camping there, this is OK, but if there are campers, I urge against it. If no one is there, a telephoto can capture the delicate falls on the right. The composition is good, but not great.

Bright Yellow Witch's Butter

50mm f/2.8 1/50s ISO200

★**World's Largest Sitka Spruce:** The world's largest?! Yeah! This sounds awesome, and it does deliver as *a tree to be seen*, but for photographers, it's lacking in "depth." To say it clearly, there's no foreground and no background. And to complicate matters, its scale is just not at all evident when photographed by itself. The solution? Take a self portrait or a family/friends photo in front of it. Below I have assumed my very best "tree hugger" pose. (I have to laugh... I tried several poses, because in some I looked like a bug splat onto the windshield of a car! This was the best, intimate pose I could produce.) So, if wanting to place yourself or friends and family, be sure to get as close to the tree as possible, as to not distort its scale but rather to highlight it. Some fun facts about this tree... It is about 1,000 years old and over 190 feet in height. It's circumference is pushing 59 feet! If circular this would equate to a diameter of over 18 feet!!! Accessing the spruce is straightforward and well-marked from South Shore Road. Based on the side we all photograph, it's best in the morning. Figure ~0.5 miles (round trip), minimal elevation change, and ~30 minutes.

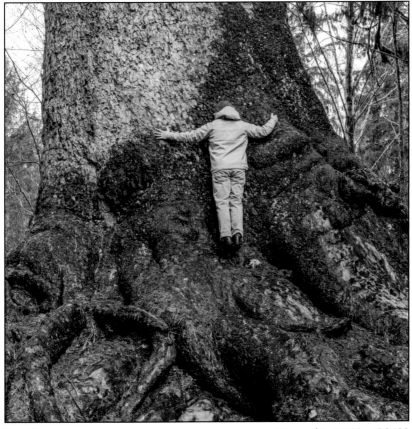

Tree Hugger 35mm f/8 1/100s ISO400

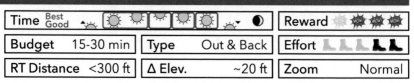

Time	Best Good							Reward			

Budget	15-30 min	Type	Out & Back	Effort				

RT Distance	<300 ft	Δ Elev.	~20 ft	Zoom	Normal

Merriman Falls is perhaps the most popular waterfall in this south shore area because it has a single, vertical drop with respectable height. From a photographer's perspective it's also great in that at least **four compositions are possible** around this one, small site.

Parking for the falls is on the west end of the guardrail, alongside the road.

If we orient ourselves from the road, looking straight upon the falls in the background, some positioning will provide the first composition (and probably my favorite) with the waterfall "framed" between two trees. Depth of field poses a challenge here since the trees are relatively close to you and the falls are back a ways. Unless you desire to focus-stack multiple exposures, my advice is to set focus on the boulders low in the frame behind the trees and stop your aperture down some to help bring the trees and the falls to within reasonable focus. This is what I have done for the photo on the next page.

A second composition may be made from a left-side approach (east of the creek), scrambling part of the way up the big rocks. **Be extremely careful if pursuing this option – the rocks here are always slippery.** Allow for the rocks near the top of this pile to provide your foreground. They're covered in moss, so of course they're prime candidates for the rain forest and waterfall scene before you.

From a right-side approach (now west of the creek) there is ample space to work. One composition is perhaps immediately evident, to the far right of the creek's water flow. Another composition is possible, still waterside but closer to the road. A lot of the waterfall is blocked with this perspective, but more interesting foreground elements present themselves.

When I photograph waterfalls I almost always employ a stopped-down aperture, to help slow the shutter speed and also add depth of field. Merriman Falls is not kind in this department (with this strategy). The water flow, no matter the season, always has a powerful mist that likes to stir the nearby trees' leaves and ferns. If you like the apparent "movement" in your photograph, you'll be delighted. If you don't, then take multiple exposures so that once back home you can pick one that best suits your tastes.

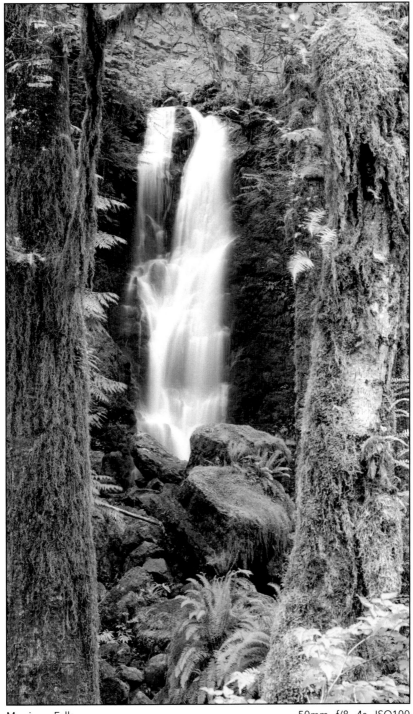

Merriman Falls

50mm f/8 4s ISO100

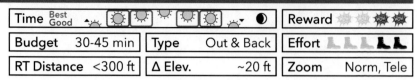

Time Best/Good		Reward
Budget 30-45 min	Type Out & Back	Effort
RT Distance <300 ft	Δ Elev. ~20 ft	Zoom Norm, Tele

Just inside the boundary of Olympic National Park, Bunch Falls is the final waterfall stop along South Shore Road. The falls can be seen from the road but are back in the forest a bit, further away than Merriman Falls (5) when roadside.

Compositions here require a little more consideration or "trial-and-error" than at Merriman Falls, hence the added budgeted time at this location. Before discussing the two most common compositions, let's first address the "seasonal" element for this site...

Vine Maples are scattered along the creekside, so between mid-spring and early fall you can expect either abundant leaves, in some combination of green, yellow, orange, and/or red. From mid-fall through early spring, however, their limbs are bare – and admittedly detract a bit from the vibrant scene, which is otherwise year-round. So, this is not to say that the site is only suitable for visiting while the vine maples have leaves but rather how you want to compose your photos to either include the trees or eliminate them from the frame.

Parking is available on the east side of the creek. A slippery and sometimes muddy walk is ahead... **Wear appropriate footwear and be extra cautious while walking on the rocks – even the ones that may look dry are probably as slippery or even more so than the wet ones.**

Once down near the creek an abundance of rocks allows for an approach and tripod setup just above the flow of water. This is my favorite perspective, even though the falls will appear a bit distant. Try a variation of focal lengths here, as well as other camera positions and settings. The results vary substantially. ...As noted above, regarding the Vine Maples, if the bare limbs create a distraction, try zooming-in on the falls here, past the proposed foreground.

Most visitors continue along the somewhat rough route at the right, in order to photograph closer to the falls. This is good too but lacks many of the interesting foreground elements provided when shooting from further downstream as before. (Perhaps when the Vine Maples aren't agreeable, this becomes the better composition.)

Take your time at this site. Mild juxtapositions in your subjects (near or far) and camera settings will result in remarkably different results.

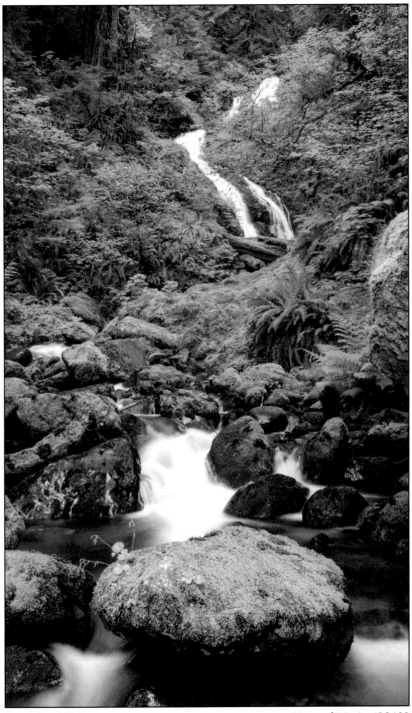

Bunch Creek Falls

35mm f/16 6s ISO100

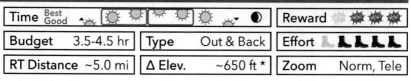

Time	Best Good								Reward			
Budget	3.5-4.5 hr			**Type**		Out & Back			**Effort**			
RT Distance	~5.0 mi			**Δ Elev.**		~650 ft *			**Zoom**		Norm, Tele	

* Notable elevation gain and loss. See elevation profile, page 135.

The drive to the Graves Creek Trailhead, which accesses Pony Bridge, is advertised as 17 miles or ~50 minutes from the Lake Quinault Lodge. Expect every minute of that to be accurate. This surprised me the first time I visited. It just doesn't seem that this drive would take so long!

The good news is that it's an interesting drive, especially once past the bridge to North Shore Road. If traveling early in the morning, expect to encounter Roosevelt Elk along the way. Below is a herd of cows crossing a section of the Quinault River along this drive. *Pretty cool.*

Roosevelt Elk Crossing the Quinault River 135mm f/5.6 1/320s ISO1600

Near the end of the road, pass the Graves Creek Campground... The parking area for the Graves Creek Trailhead is soon after.

Time to gear up and head out. A bridge over Graves Creek is first up. Its surface is slippery like greased wood... Be careful and shorten your stride here. After the bridge stay on the main trail (East Fork Quinault River Trail, towards Enchanted Valley) and pass the smaller, Graves Creek Trail on the right. A single log footbridge is up next, above a tributary serving Graves Creek.

The mostly dirt trail climbs steadily, but gently, to its highest point after about 1.8 miles. Time to descend a bit towards the Quinault River and Pony Bridge. This descent is more rocky than the first section of the trail, so your pace will naturally slow some.

At ~2.5 miles arrive at Pony Bridge and look down from it to your right. What a gorgeous view of the meandering river and its teal-colored flow, along with a delicate waterfall cascading into the river. The shot from here is obvious – there are no real tricks. Do try varying your focal length and shutter speed to find the "look" you like best.

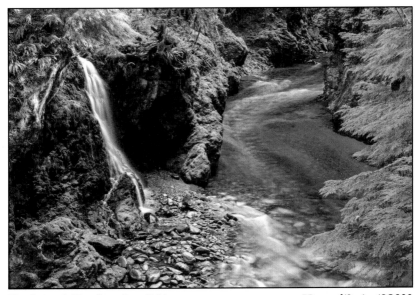

The Quinault River from Pony Bridge 55mm f/8 4s ISO200

Additional compositions await. Cross the bridge and spot a path to the left into a backcountry campground known as Pony Bridge Camp. Here you can see the river's flow alongside water-worn rocks carpeted in thick moss. A distant stream flows through the moss and can be captured with a telephoto.

Don't forget to take a photo of Pony Bridge! My favorite perspective is from this camp's path entrance, back near the main trail. Seen here, *with flare!*

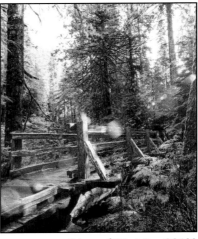

24mm f/22 1/4s ISO100

Time	Best Good					Reward	✸ ✸ ✸ ✸
Budget	1-2 hr	Type		Loop		Effort	⚊ ⚊ ⚊ ⚊ ⚊
RT Distance	~1.5 mi	Δ Elev.		~30 ft		Zoom	Wide, Norm

Not far off of Highway 101 along the North Shore Road is a pair of trails managed by the National Park Service that is a **must do** if in the Quinault area. Though the trails are regularly advertised as separate, the Kestner Homestead trail loop contains a portion of the Maple Glade trail loop, and given that they're both great I consider them as "one" for our purposes here. However... If you are either short on time or you feel inclined to forego a historical homestead property, it is reasonable to only visit Maple Glade. The Maple Glade loop is ~0.5 mile with negligible elevation change.

The Kestner Homestead dates back to 1891. Anton Kestner, his wife Josepha, and their seven children transformed this land into some of what we can still see today. I will list some of the structures still present momentarily... If you have to luxury to pick up one of the Kestner Homestead trail brochures at the visitor center in Port Angeles, I highly recommend doing so. It provides an interesting narrative on the family, the property, and its change in hands over the last century.

Maple Glade's most prominent feature is its shallow pond, presumably where its name came from. (If we consider the Florida Everglades for inspiration, as "glade" otherwise only normally refers to simply a clearing in a forest.) The pond here is normally quite still and produces sensational reflections on its surface.

One caveat to this location... Occasionally, heavy water flow along Kestner Creek can *truly overwhelm* this entire area. I would steer clear if upon your arrival there is water running in abundance over North Shore Road and/or near the trails' entrances. Try another day or time.

Trails access is at the Quinault Rain Forest Ranger Station (aka the Quinault River Ranger Station, per the signage along North Shore Road). Once parked, take a look at the trail map provided on the information board in front of the parking area for orientation. Our grand loop will take you counterclockwise on the Kestner Homestead trail, leaving the parking area on the right (if facing the forest).

Hop onto the Kestner Homestead trail and begin your journey adjacent to Kestner Creek, through a forest of ferns and trees covered in moss. This hike will crescendo in photographic interest... While this section is interesting, do budget your time for what's ahead. It gets better.

At ~0.4mile reach a turn-in off South Shore Road and a 2-car parking area for the Kestner Homestead. Turn left, and head over the bridge towards the now-visible buildings.

The family's house greets your arrival. This house was constructed between 1900-1905. *At time of writing, its interior is undergoing a period renovation for access in the near future.* Attached to the rear of the house is an interesting walk-through, prior used for storage. To the house's left (west) is the root house, which also contains a curious, two-seat outhouse. Left (west again) of the root house is a modern resemblance of the original barn, now serving as a covered picnic area. Behind (north of) the root house are several additional artifacts and buildings... From left (west) to right (east), a rusted-out moving truck, a utility shed & smokehouse, and a vehicle repair shed with accompanying ramps for servicing from below.

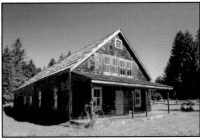
24mm f/8 1/125s ISO200

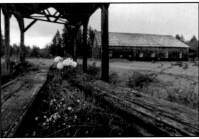
35mm f/4 1/20s ISO3200

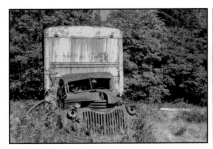
50mm f/11 1/60s ISO100

16mm f/8 1/80s ISO200

Once your exploration is complete, follow the well-worn path west and re-enter the forest. There are some more narrow trails that intersect the main loop along the way. Ignore them; remain on the well-beaten trail.

Make your way further into the forest and notice the abundance and density of sword ferns. Nowhere in my Pacific Northwest travels have I seen such a heavy concentration of ferns like found here. Remember to occasionally look behind where you have just walked from, as sometimes a great composition may have materialized over your shoulder.

Finally, you will reach a fork in the trail, where the Kestner Homestead loop connects with the Maple Glade loop, denoted by a sign pointing both directions to the Ranger Station. Take the path to your left.

Soon, come upon the wetland. Access closer to the water is available off the main trail in many places. A variety of compositions is possible here, thanks to very many places from which to photograph. Take your time and enjoy exploring on and off the trail. A polarizer helps here, balancing the flora in the water with the reflections on its surface.

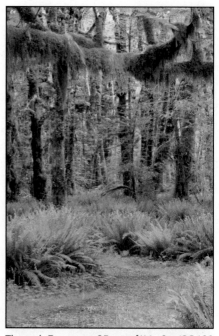

Through Ferns 35mm f/11 2s ISO100

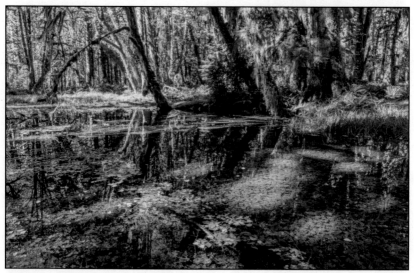

Fall Colors Afloat on Maple Glade 24mm f/16 0.6s ISO100

If you continue around the path you will come upon another intersection. This is near the "beginning" of the Maple Glade loop. Turn left to exit and head over the foot bridge, or turn right and explore the other half of Maple Glade. I can say though, with some certainty, that you've already seen the very best Maple Glade offers.

Time	Best Good									Reward			

Budget	15-30 min	Type	Roadside	Effort

RT Distance	<300 ft	Δ Elev.	<10 ft	Zoom	Telephoto

As we know, Olympic National Park encompasses mountains, rain forests, and coast. I love this photo because it's the only place I know of within the park to at least capture two of these sensational environments into one composition.

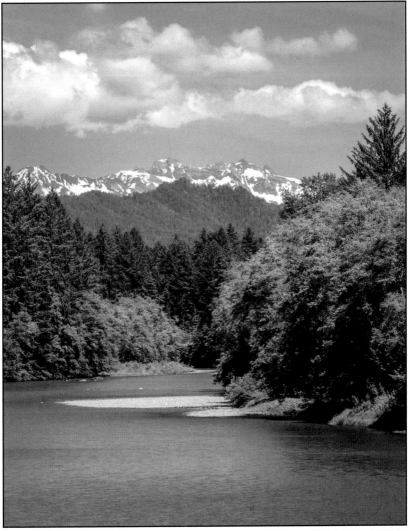

Queets River and the Olympic Mountains 200mm f/8 1/250s ISO200

Admittedly, I envisioned this photo (on the prior page) to be this book's cover, for this reason alone – encompassing two key, unique ecosystems within Olympic National Park.

I instead selected Sol Duc Falls because I think it's more sensational, but not without some hesitation on my part. *Herein lies some insight into the choices made editing a book!*

The Queets River meanders toward its mouth to the Pacific Ocean near the community of Queets. Here though, this straight, ~¼ mile stretch of the river aligns perfectly with the Olympic Mountains, some 30 miles in the distance. And bonus – the vista is truly roadside!

For what can be a straightforward photo to take there are some key elements to discuss...

First, the weather. In order to capture the entire ~30 mile view, clear skies are a must. Well, by "clear" on the peninsula, high clouds are of course OK, but what I really mean is no low clouds or fog. This is a tall order most months of the year. Hey, this is a rain forest area – can you expect otherwise? Summer months have the highest concentration of good visibility days, but clear skies do happen occasionally other times of year as well. My point is, if you're in the area and are interested in checking out this vista, be mindful of current conditions. (Do not waste time with the drive in, albeit short, if the skies are gray.)

Time of day also plays a role. This advice isn't as foolproof as what's provided above (so you may experience otherwise), but even on clear days the skies typically don't like to *really* clear up until late morning. Sunrise through early morning there just tends to be too much low altitude humidity to allow for this ~30 mile capture. Here is one spot where midday is actually great.

From Highway 101 the signage to "Lower Queets Valley" is clear. Turn off the highway onto the gravel Queets River Road. The first ~0.5 mile is through the Quinault Reservation, until you reach the unmanned Olympic National Park entrance. Continue another ~1.7 miles to the vista. I promise, you will know it when you see it. Parking is available on a widened shoulder just another ~150 feet past the clearing.

There are two clearings to photograph from. The first, which you un-doubtedly noticed on your approach and another just a short walk away. It all depends on what you want in frame... The photo on the prior page is from the clearing on the right. The first clearing (on the "left") provides forest lining the north bank of the Quinault River.

Try both locations and various focal lengths to see which you like best. Since the mountains are quite distant, be mindful of where you select focus for "hyperfocal distance" (or everything in focus).

West

Kalaloch to Hoh and Rialto Beach

Bridge to Beach 4 50mm f/16 0.5s ISO50

Time	Best Good									Reward	✹ ✹ ✹ ✹

Budget	30 min	Type	Out & Back	Effort	👢👢👢 👢👢

RT Distance	~600 ft	Δ Elev.	~20 ft	Zoom	Normal

Words cannot do this marvelous tree justice. A Sitka Spruce, defying its life's end. I hope it can continue to resist weather and gravity for years to come, for many more visitors' amazement.

To access the "Tree of Life," turn off Highway 101 into the well-marked Kalaloch Campground, ~½ mile north of the Kalaloch Lodge. The trail to the beach is found on the west end of this day use, teardrop-shaped parking loop.

This is one beach site that is **suitable for even higher tides.** (Rejoice!) Follow the path down to the beach and carefully navigate the final, steep steps and driftwood... Continue "straight" (north) and you're almost immediately there.

Part of the erosion beneath the tree is from a stream flowing through the campground above. Sometimes its flow is so great that it is visible in the photograph. (In my photo below, it is not.) Of the many photos I have, I enjoy this one because of the delicate clouds to the east.

This stop doesn't take long. As such, plus the Tree of Life's awesomeness, I consider it a **must do**.

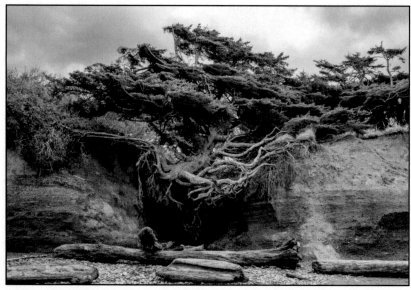

Kalaloch "Tree of Life" 28mm f/5.6 1/15s ISO100

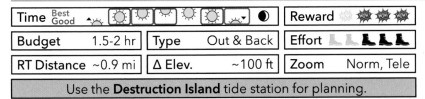

Time	Best Good									Reward	
Budget			1.5-2 hr	Type		Out & Back	Effort				
RT Distance		~0.9 mi	Δ Elev.			~100 ft	Zoom		Norm, Tele		

Use the **Destruction Island** tide station for planning.

What happened to Beach 1, Beach 2, and Beach 3? *Hey, this isn't an all stops tour of the coast – this is a best of.* I do enjoy the Spruce burl found adjacent to Highway 101 at the Beach 1 stop, but when it comes to beaches, none of the rest of these compare to Beach 4.

Beach 4 checks several boxes... 1) **The best, *easily-accessible* tide pools in Olympic National Park,** 2) truly unique geo- (rock) features, and 3) splendid sea stacks for sunset silhouettes. The sunset photo on the inside cover of this book was taken at Beach 4.

Before carrying on, I should clarify the first point... Rialto Beach (18) may have tide pools equitable in quality but requires a much longer hike. Shi Shi Beach (19) (Point of the Arches) provides similar (if not even better) tide pools but again requires quite a longer hike. Tongue Point (31) is arguably the best for tide pools on the Olympic Peninsula, but is not technically within the national park.

Beach 4 is well-marked off Highway 101, and the parking area is large. (While some "undiscovered" sites may host small parking areas, this one has a large area because, well, Beach 4 is undisputedly great!)

Once you leave your vehicle and begin, immediately there is a fork – a trail to the right and a trail to the left. The trail to the right takes you to an "overlook" of the beach below. While interesting, it lacks a bit in photo worthiness. Take the trail to the left and begin your way downhill towards the beach. This is a semi-lengthy descent. While easy going down, you may feel inclined to take a break on the steady ascent later!

Arrive at the most spectacular bridge in Olympic National Park (in my honest opinion), as partially seen on page 59. How cool! This is your portal to the beach below, but first after trekking over the bridge you will have to descend some ~20 million year-old turbidites (sedimentary rock layers). Take your time here... Carefully select your rockery "steps" to descend, using your feet *and hands* as required. Once on the sandy beach, assess the formation you came down. Amazing.

Time to move on... There are three options immediately present. First, during low tide towards the ocean ahead of your descent from the bridge find a huge, exposed turbidites formation. While gorgeous, if you are here during low tide and feel inclined to photograph this

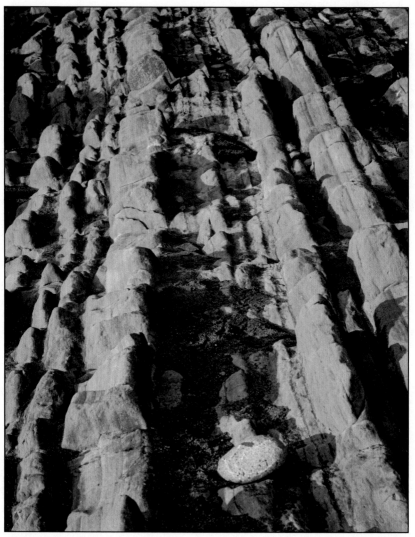

Overturned Turbidites 80mm f/8 1/80s ISO200

I recommend to work quickly and be sure to get to the tides pools ASAP. The second option is tide-independent, and that's a marvelous, little cascade of water beneath the aforementioned bridge. Finally, of course, are the sea stacks just to your north. To the sea stacks we go!..

As implied in my list on the prior page, I believe the tide pools here are the real draw. Please be sure to review my tides section on page 33. My timing here has always been to arrive 30-60 minutes prior to low tide. Make your way towards the right side of the tallest sea stack. **Be cautious - as you begin to navigate atop the sea stacks steer clear of surfaces black and dark red in color. These areas are**

extremely slippery. On one visit I slipped, prior to learning this, and ended up with several bloody knuckles. I was lucky it wasn't worse. As such, I always recommend stowing your gear while you walk, so that your hands are free to assist in safely traversing these areas.

My number one piece of advice for tide pools is to go as far out as safely possible (as the tide and any "sneaker waves" will allow), as the sea life becomes more abundant where the water *was* deeper. In other words, do not arrive and immediately become fixated on the first sea life you encounter – unless of course it's extraordinary! Make your way towards the water level and see that as you move to the water's edge things get more and more interesting.

In my experience photographing tide pools at Beach 4 (and Rialto Beach) I most often am reaching for my telephoto lenses for the necessary "reach." The tide pools in this area do not regularly allow positioning yourself close to the sea life. A polarizer is almost a must, so as to cut any reflection from the water and to enhance the colors.

Regarding sunsets at Beach 4... The only real "trick" is to be sufficiently close to the water-saturated beach for that mirrored color in the sand. This may make for wet feet or sinking tripod feet, so monitor any changing water level as you shoot.

Sea Star & Anemones 400mm f/4 1/60s ISO800

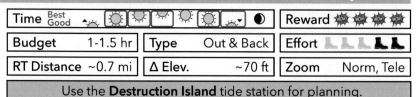
Time	Best Good		Reward		
Budget	1-1.5 hr	Type	Out & Back	Effort	
RT Distance	~0.7 mi	Δ Elev.	~70 ft	Zoom	Norm, Tele

Use the **Destruction Island** tide station for planning.

Ruby Beach may very well be the most popular beach in Olympic National Park, *if considering visitation numbers alone.* It is right off of Highway 101, it offers alluring, panoramic views from the picnic and parking areas, and the path down to it is suitable for most people. **Abbey Island**, the largest sea stack along this stretch of highway, is close and makes for easy compositions.

Tide pools... You will surely come across reports of great tide pools at Ruby Beach, but in order to access them you must cross Cedar Creek as it spills across the beach from the elevation above. This water is not only routinely ~2 feet deep but also has significant flow that makes passage challenging. I recommend against it and instead prefer the "dry" access to the tide pools at Beach 4.

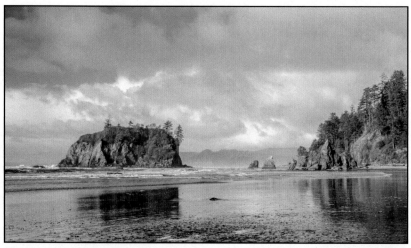

Abbey Island & Ruby Beach 35mm f/16 1/30s ISO100

The trailhead from the parking lot is obvious, and the path offers multiple viewing areas on the way down. Though the route is somewhat encased in trees, there are some pleasant compositions possible... Consider metering on the beach scene in the distance and allowing for the trees in your field of view to be silhouettes (in their darkness).

Once the trail ends, carefully navigate the **abundant driftwood** in order to reach the beach ahead.

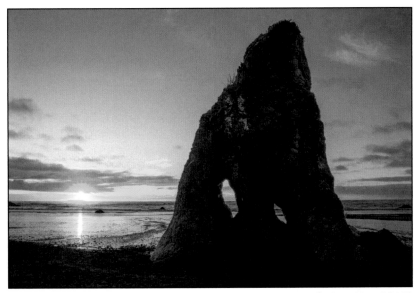

Sea Stack Eyes 24mm f/22 1/20s ISO100

Find a sizable sea stack with holes in it right when you reach the beach. It makes for an interesting subject any time of day.

Sunsets are brilliant here. The shots above and below were taken in December only 10 minutes apart. Remember a headlamp for the walk back, over the driftwood and up the hill.

Sunset & Destruction Island 100mm f/22 1/100s ISO200

Coincidentally, I employed a narrow aperture on the three photos I have shared. That was not by design. I used the small aperture on the Abbey Island photo for depth of field and on the two sunset photos for a starburst of the sun. The effect was almost imperceivable on the Destruction Island photo. Oh well – I still like it!

Time	Best Good								Reward			
Budget	15-30 min		**Type**		Roadside		**Effort**					
RT Distance	<500 ft		**Δ Elev.**		<10 ft		**Zoom**		Telephoto			

Near the end of your Upper Hoh Road journey lies a usually calm body of water on the left side of the road about ¼ mile from the Hoh Rain Forest Visitor Center (and its parking lot). I've yet to find a name for this body of water on any map, and since Taft Creek flows into it I'm running with "Taft Pond."

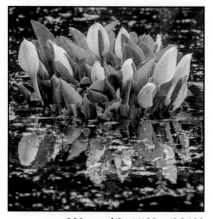

I'm always eager to see what's going on here. It's been a productive stop for me on the majority of my visits to the Hoh.

Elk are a common sight along its east end. Many types of birds frequent the area, and of course there's interesting flora in and around the entire pond. At right is a large Skunk Cabbage bloom in April.

There is ample shoulder space to park roadside along the length

300mm f/8 1/100s ISO400

of the pond. Alternatively, it is a short walk from the main parking lot.

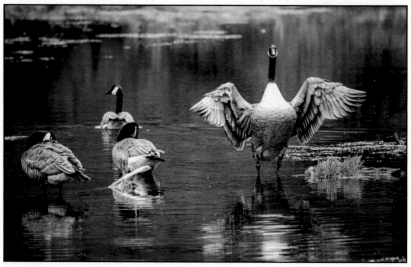

Silly Goose 400mm f/4 1/160s ISO800

The subjects here are typically distant. Every photograph I have from Taft Pond was taken using a telephoto lens. Below is a Vine Maple in autumn at dawn. I relied on a higher ISO and a tripod to manage a reasonable shutter speed to combat a light breeze.

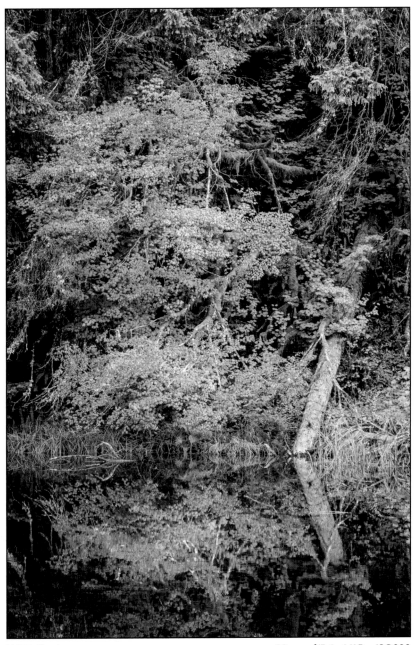

Fall Reflections 80mm f/5.6 1/15s ISO800

Time	Best Good									Reward	✹ ✹ ✹ ✹

Budget	1-2 hr	Type	Lollipop Loop	Effort	🔦 🔦 🔦 **🔦 🔦**

RT Distance	~1.0 mi	Δ Elev.	~90 ft	Zoom	Whole Kit!

The Hall of Mosses is quentissential Olympic. It is *the* must do.

The Hoh Rain Forest encompasses some 20+ miles along the Hoh River, yet when we think of "The Hoh" we conjure images taken from within the Hall of Mosses and its accompanying trail. The "hall" is a short section of the greater loop where you enter, walking under a whimsical arched, mossy tree (the doorway), and continue into a "great room" of ferns and towering maples with abundant moss. This is the very best, easily-accessible part of this sensational inland, temperate rain forest. Making the best of it though, as a photographer, is not without challenge.

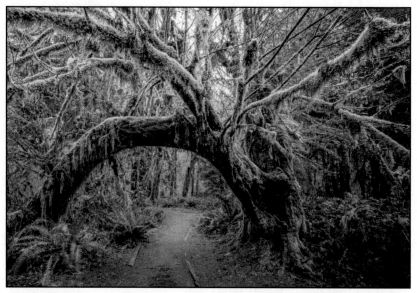

Doorway to Hall 15mm f/8 4s ISO100

Lighting is key here, but at least it is one element that you have some command over. The Hoh is typically at its best in the late afternoon, towards sunset. Early morning light is a distant second, though still workable. Morning light, once it illuminates the area enough for photography, comes quickly and with intensity. This is because the mountains to the east block the earlier, softer light. Once the light clears the mountains it already is so strong that the scenes at you and your camera's disposal tend to have excess contrast. Midday is a bust.

While rain is to be regularly expected, the aftermath of *heavy* rain results in flattened ferns on the forest's floor. This is not a deal-breaker, but smushed ferns can detract from your foreground capture. See also the seasonal commentary in the Tips & Techniques section... The most luscious greens are in May and early June.

Trail access is adjacent to the visitor center. Thanks to the "Mini Trail," however, the Hall of Mosses trailhead feels a bit elusive once you're on site. Either begin near the visitor center's entrance or at the large reader boards closer to the parking lot. Stay left, and signage will help prompt your direction once on the path.

Soon, cross a bridge over Taft Creek. This is a lovely composition with a fallen tree and abundant flora in the water. Fowl frequent this area. Food must be in abundance!

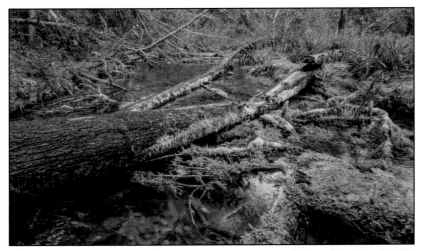

Taft Creek Swell 24mm f/8 1/8s ISO100

Bend right and climb a short bit. You will walk underneath two fallen trees. The loop entrance is next. New signage now directs one-way travel, a clockwise route. (Enter to your left.)

After a short walk find a sign to "Maple Grove" at your left. This is a short (~200 ft) and worthwhile diversion. The viewing area is set behind a split rail wooden fence; exploration of the destination is restricted. Compositions feel limited here but are pleasant. My experience at Maple Grove has been best in the fall, when the maple leaves are a warm yellow.

Back on the main loop, before you even have time to re-establish your pace, arrive at the Hall of Mosses. The entrance is marked with a reader board on the right and the arched tree spanning the trail ahead. Photographing this tree is best with ultra-wide angle focal

Autumn in Maple Grove 24mm f/11 1s ISO100

lengths (14-18mm). Try getting up close, to nearly underneath it, so that the limbs protruding from it seemingly race to the frame's top and side edges.

You have arrived. Limbs and moss are everywhere! The best advice that I can provide is to be mindful of the usually bright sky above. If you try and take in "too much" at once, the tendency is for the sky to overwhelm your composition. Position yourself precisely... Small adjustments can pay big dividends here. *Take your time.*

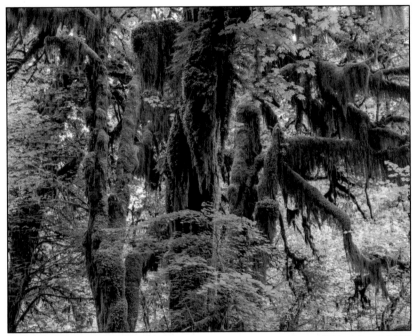

Maple & Moss in May Glory 50mm f/11 0.8s ISO100

Note the slower shutter speeds across all of these photographs. The lighting is dim throughout this area. **A tripod is arguably a must.**

There is a lot to take in, and perhaps there lies the challenge... To hone in on what you see that matters most in your compositions. Try and eliminate from your frame what isn't part of the story. (This is *easier said than done* at times, in a place with so much to see.)

When satisfied, exit the hall and continue on the loop. The grandiose scenes will be now behind you – it's time to look at the rain forest details as you continue your hike.

35mm f/2.8 1/20s ISO400

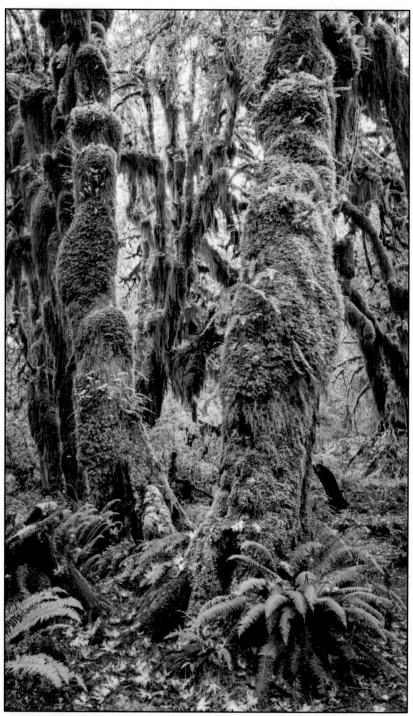

Exiting the Hall of Mosses 24mm f/22 4s ISO200

The National Park Service advertises four trails in the vicinity of the Hoh Rain Forest Visitor Center — Mini Trail, Hall of Mosses Trail (covered on the prior pages), Hoh River Trail, and Spruce Nature Trail.

Mini Trail: In places this trail is listed as ¼ mile, and others 0.1 mile. I believe the 0.1 mile is more accurate. It's more of a connector trail, serving the other three trails listed above. I have no doubt you'll walk along part or all of it during your visit. There are some interesting information boards along the way.

★**Hoh River Trail:** This is the big one of the bunch, if done in its entirety. It follows alongside the Hoh River for ~14 miles before finally crossing and heading another ~4 miles steeply up to the Blue Glacier on the north side of **Mount Olympus**. Figure ~36 miles round trip and with a total elevation gain of ~5,000 ft! This type of hike is not within the scope of this book, but I'm confident if you pursued it you would come home with sensational photos! Research further if of interest.

There are, however, noteworthy elements if you want to check out the first part of this trail.

Of note, despite its name, the trail does not follow alongside the river. It more-or-less parallels the river, but usually the river is completely out of sight.

Which brings me to my primary recommendation here, and why I have starred the route for serious consideration... At 0.9 mile is a 4x4 (inch) post and trail to the right. This short trail leads you to the river's edge. Well, it leads you to the "formal" river's edge, but under typical water flow you must trek down the shore a bit and find the usually shallow water (and rocks-for-steps) to cross to the large riverbank for up-close photography of the wide section of the river. I recommend doing this. It is the best-looking shot of the Hoh River in this area. The photograph on the page 75 is from this location. If you pursue this, and double-back to the trail's beginning, your round trip will be ~2.2 miles with ~50 feet elevation change.

Bonus: The best "rain forest" section of this trail occurs during the first ~0.7 mile, and it is divine. So if timing is limited, and you cannot make the trek all the way to the river's edge, I wholeheartedly recommend at least checking out this first stretch.

Beyond the 0.9 mile marker (to the river), the trail lacks somewhat in the reward:effort proposition. That is not to say it's not great in places, but I do recommend spending your time elsewhere. Leave the rest of this trail to those walking its entirety.

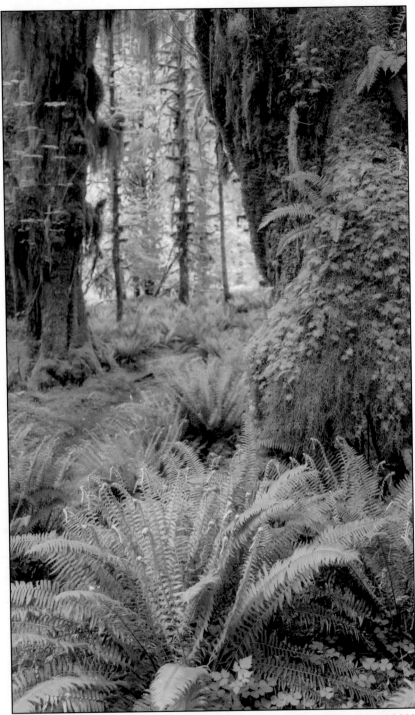

Verdant Rain Forest along the Hoh River Trail 40mm f/4 1/40s ISO800

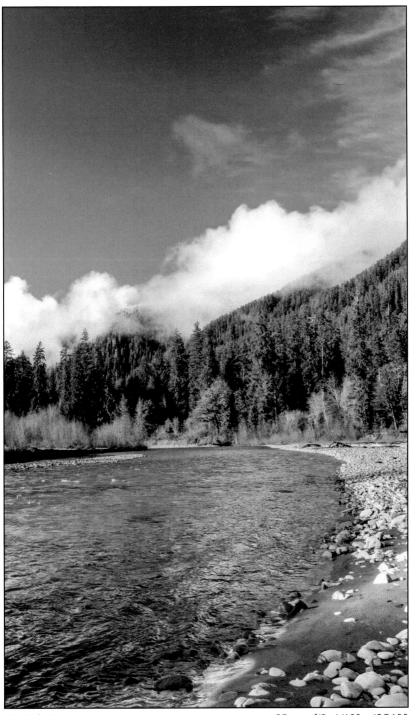

The Hoh River 35mm f/8 1/100s ISO100

One last thing regarding the Hoh River Trail... This route is often quite muddy, with a lot of standing water. I couldn't resist sharing the photo at right. Do be sure to wear waterproof footwear if pursuing this hike!

28mm f/8 1/30s ISO400

Spruce Nature Trail: When looking to pair a second trail experience with the Hall of Mosses I suspect this is most visitors' election. I want to recommend otherwise. Its allure is that it is a short loop, ~1.2 miles with negligible elevation change. But when compared to the Hoh River Trail, either only through the delightful rain forest experience at its beginning or all the way to the river's edge, it falls a bit short. The forest nor the riverbank on the Spruce Nature Trail is as photogenic as those compared to on the Hoh River Trail.

The one area that it can shine is in closeup photography. Nowhere else in this area have I so regularly come across so many slugs and mushrooms. On one trip I found a coiled-up garter snake. (These are harmless.)

Slug on the Prowl 150mm f/8 1/160s ISO1600

There are also several fallen spruce trees, which provide for a great, closeup view of their interesting bark pattern.

Time	Best Good	☼ ☼ ☼ ☼ ☼ ☼ ●	Reward	🎆 🎆 🎆	
Budget	1.5-2 hr	Type	Out & Back	Effort	🔋 🔋 **🔋 🔋 🔋**
RT Distance ~1.7 mi		Δ Elev. ~200 ft *	Zoom	Norm, Tele	

Use the **James Island** tide station for planning.

* Notable elevation gain and loss. See elevation profile, page 135.

There are three listed beaches in and near the community of La Push; from south to north, Third Beach, Second Beach, and First Beach, respectively. Please see pages 22-23 for further commentary.

Second Beach is the best among these three for photography. I like the numerous sea stacks here and the headland to your right (north) with the natural bridge. Waves of seawater flow vigorously through the rock gap at average and high tides. Because of this, **Second Beach makes for a good site to visit if your coastal timing doesn't coincide with a low tide (here or elsewhere).** Tide pools do not seem to have as much to see as some of the other beaches listed in this book, but they are still good.

The trail is identified by a brown sign along La Push Road. Unfortunately, the parking area is quite small. The path through the forest is short and enjoyable, as it zigzags a bit while first climbing then descending to the ocean shore. Once at the beach, study the portal from trees to sand... It can be difficult to locate when ready to leave!

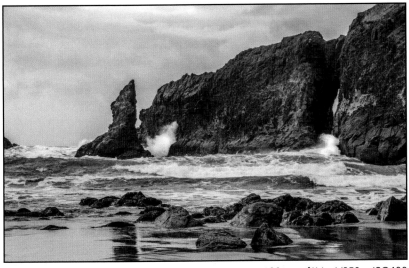

Second Beach Headland 120mm f/11 1/250s ISO400

Time Best Good		Reward
Budget 45-60 min	Type Lollipop Loop	Effort
RT Distance ~0.4 mi	Δ Elev. <10 ft	Zoom Norm, Tele

The name's Pond... James Pond. *(This gets me every time.)*

If you're visiting Rialto Beach, the short James Pond trail is a pleasant, complimentary add-on. In under a half mile, zigzag under a thick canopy of trees, discover mushrooms (in abundance), and come upon a hidden pond with interesting features and occasional wildlife.

Parking is available at the Mora Ranger Station, and the trail entrance is on the north side of Mora Road (the road to Rialto Beach), directly opposite the campground entrance. Look for the small "James Pond" sign.

Once on the trail and not too far in, arrive at the loop's beginning and end. I prefer a counterclockwise route and therefore go right.

Immediately after a bench look for a spur trail leading over two short, wood bridges to the water's edge. A fallen tree provides closer water access, though be extremely careful if you choose to proceed.

After surveying the pond, track back to the main loop and continue around back to the junction, this time turning right to exit.

Delicate Mycena 300mm f/11 8s ISO200

Bring a tripod to allow lower ISO (and consequently long shutter speeds) for mushroom photos.

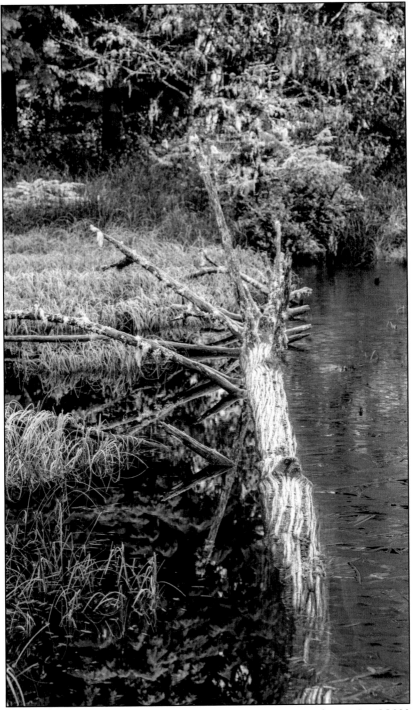

Frosty Fall Morning on James Pond

100mm f/8 1/60s ISO200

Time	Best Good	☀ ☀ ☀ ☀ ☀ ◐	Reward ✸ ✸ ✸ ✸		
Budget	3-4 hr	Type	Out & Back	Effort ▲ ▲ ▲ ▲ ▲	
RT Distance ~3.5 mi		Δ Elev.	~40 ft	Zoom	Norm, Tele

Use the **James Island** tide station for planning.

This was one of the more difficult sites to edit, because there are so many great photos to choose from! Though, in order to experience all that Rialto Beach has to offer, exploration at low tide is a must.

A visit to Rialto Beach can take one of two forms... Either just around the driftwood-covered shore, not even 100 feet from the parking area in 30 minutes or less, or add the lengthy walk north along the beach to Split Rock and Hole-in-the-Wall for abundant tide pools.

I have already shared two photos from the lengthy route – Split Rock on page 9, and tidewater near Hole-in-the-Wall on page 36.

Unique to Rialto Beach is its early morning light potential. This is thanks to the lower elevations to its east (La Push and vicinity). This is the best time of day to photograph driftwood, if interested in a composition with the shoreline and ocean to its west and north.

Rising Sun on Rialto Beach 135mm f/22 1/160s ISO200

Some of the driftwood logs are so intensely red you would think they were painted, but of course they are not. The early morning light helps to amplify these logs' color.

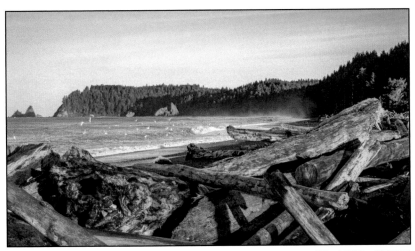

Red & Orange Meet Blue & Green 70mm f/8 1/250s ISO200

The rock formation nearest the center of the image above is Split Rock. Hole-in-the-Wall is visible just behind it, to its left. The walk there is along the beach, and it is tedious at times because the sand and rocks give so much with each step.

If your "beach pace" is like mine, it's at best ¾ of my usual speed. At about 0.8 mile reach Ellen Creek. Typically there is a large log that can be used for crossing. Use your best judgment; it may only be safe to cross through the water where it's most shallow. After another ~0.4 mile reach Split Rock. This is a great place for a short break and a few photos. Hole-in-the-Wall is within sight and another ~0.2 mile.

Assuming you reach Hole-in-the-Wall with a lower tide, you can navigate around (or through!) it to the opposite side. In doing so, check out the marvelous, saltwater-polished rock along its south side. Once to the other side you'll see that it's possible to continue to hike further north, but there's so much to see around Hole-in-the-Wall I consider it our end point.

The tide pools here are sensational. As I've said on page 33, timing is critical – arrive before low tide, so that you have time to work your way out to the best tide pools, and then retreat once the water level returns. So as not to have page after page of sea life, I'll leave a nice seastars and anemones photograph in the next site, Shi Shi Beach (19). Tide pools' life is similar between these two sites.

If your low tide timing is before sunset, you're in for a real treat. I find that composing interesting shots of Hole-in-the-Wall is a bit difficult during the daytime, but it becomes more interesting one the sun starts to set. The tide pools reflect the bright sky to the west. On the following page, I had set up on the north side of Hole-in-the-Wall.

Polished Rock 50mm f/11 1/30s ISO800

Also, if timing in on your side, Split Rock and the wet sand surrounding it makes for another good sunset subject.

Wearing/packing layers of clothes is wise for this outing, as well as a flashlight or headlamp, if a dawn or dusk excursion is in order.

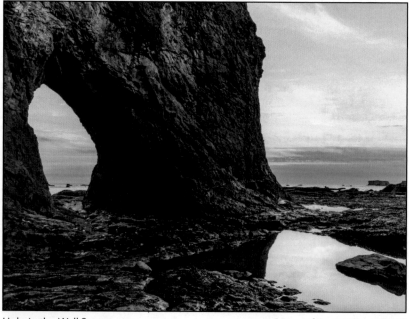

Hole-in-the-Wall Sunset 24mm f/8 1/125s ISO100

Northwest

Beyond Neah Bay

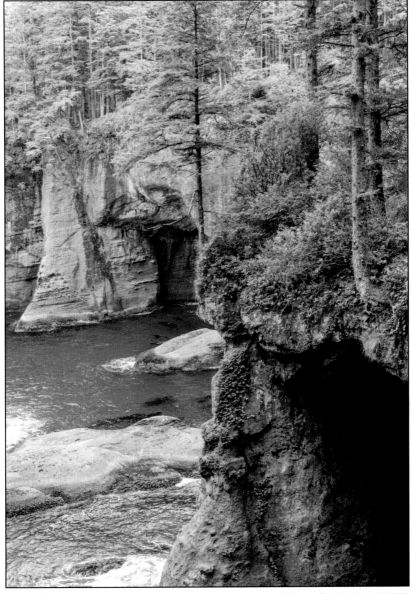

Cape Flattery 50mm f/4 1/80s ISO200

Time	Best Good								Reward			

Budget	5-6 hr	Type	Out & Back	Effort

RT Distance	~9.3 mi	Δ Elev.	~190 ft *	Zoom	Norm, Tele

Use the **Tatoosh Island** tide station for planning.

* Notable elevation gain and loss. See elevation profile, page 135.

At ~9.3 miles round trip, Shi Shi Beach to the **Point of the Arches** is the longest hike in this book. It is sensational, but I only recommend it if you can time your arrival for very low tide conditions (below 0 feet).

A Makah Recreation Permit is required for trailhead access; see page 23 for more information.

From the parking area begin hiking due west through an interesting forest and over *many* boardwalks. **These boardwalks can be deceptively slippery. Shorten your stride and slow down when on them.**

There are two trail intersections to be aware of. The first arrives after about 0.7 mile... To the right is private property, so continue to the left. (Your journey begins its southerly direction for the duration of the hike.) The second is not long after, at about 0.8 mile. This intersection is more substantial; turn right at it and soon after begin an uphill climb.

Mud can be a bit of an issue along this hike and will be at its worst up and over this hill. **Waterproof boots are a must.** (Shoes may not be adequate.) Reach the highest point at about 1.2 miles. After descending, at about 1.7 miles it levels off. This is where you cross the national park boundary. Some peekaboo views of the ocean will be at your right. After about 2.0 miles of hiking reach a national park information board and stairs for the final descent to *near* the ocean.

I say "near" the ocean because the final trek out of the forest is through multiple backcountry campsites sheltered under trees. This section is short. Finally, at about 2.2 miles you emerge from the trees and brush onto the beach. Take note (maybe a photo!) of where you exited... It can be difficult to spot later on your exit without a landmark in mind.

You will spot sea stacks to your right (north) and further ones to the left (south). It is to the south where you're heading – those sea stacks are the Point of the Arches. They are more than 2 miles away!

Before setting off for this lengthy beach hike, I recommend to have your telephoto lens mounted to your camera. Often there are a lot of Bald Eagles along this shoreline. I have captured some memorable photos of them here. (The photo on page 34 is from along this route.)

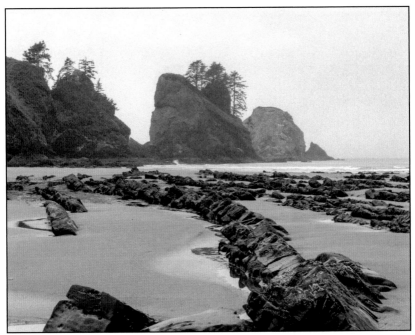

Turbidites and Point of the Arches 50mm f/8 1/80s ISO100

This walk along the beach is flat, but unlike the journey to Hole-in-the-Wall at Rialto Beach (18) at least there aren't any water crossings.

On your final approach find a large cluster of turbidites, making for an excellent foreground, leading your eyes to the Point of the Arches.

The route ends here, between where the sea stacks approach the headland. Any further pursuit traveling beyond the Point of the Arches and south is impractical and perhaps even dangerous, given the topography and risk of becoming trapped by a returning tide.

The beach around the sea stacks at Point of the Arches is generous, perhaps more so than any other tide pools location I have found. It is relatively easy to walk around, looking for exposed sea life at beach level.

Point of the Arches' name reflects the number of "arches" found among the sea stacks, weathered-away from wind and water. Some are distant though, and are impractical to access.

70mm f/8 1/250s ISO100

Suspended Sea Anemone 150mm f/4 1/100s ISO1600

Sea Star & Friends 55mm f/8 1/60s ISO800

Time	Best Good								Reward 🏵 🏵 🏵 🏵

Budget	1-2 hr	Type	Out & Back	Effort 🔅 🔅 🔅 **🔅 🔅 🔅**

RT Distance ~1.4 mi	Δ Elev.	~280 ft	Zoom	Norm, Tele

If you can afford the time to drive to this far corner of the Olympic Peninsula, I highly recommend a visit to Cape Flattery for its stunning views. The trail leads to multiple viewpoints along a cape (headland), perched some 40-60 feet above sea level. Water access is not possible, and so for our purposes the tidal conditions are arguably irrelevant.

A Makah Recreation Permit is required for trailhead access; see page 23 for more information.

From the large parking lot, follow clear signage along the wide trail as it gently descends under a canopy of trees. The trail eventually narrows, as you make your way across multiple boardwalks and down a short, rocky section.

Reach the fun, candelabra-shaped tree (page 11) and find the first viewing platform to the left. Three additional platforms await, with the one at the "end" facing Tatoosh Island and its lighthouse.

Photography from these platforms is straightforward, though from

Luscious Sea Stacks 70mm f/5.6 1/400s ISO200

some vantages there may be limbs from nearby trees impeding your views a bit. For the photo on the prior page, I attached my camera to tripod, triggered my shutter with a 10s timer, and elevated the tripod and camera above my head for a clearer view. Just hold on tight!

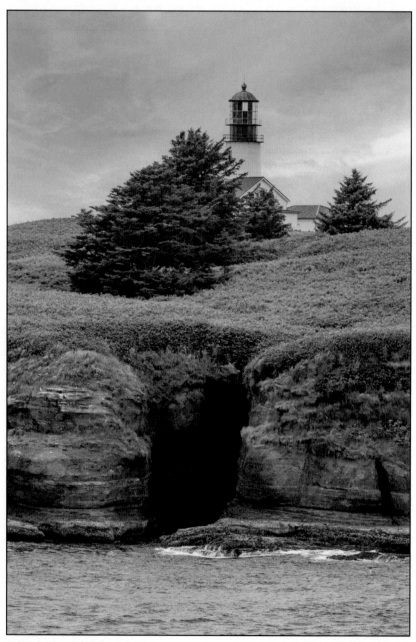

Tatoosh Island & Lighthouse 400mm f/5.6 1/640s ISO400

North

Sol Duc to Deer Park

Last Light on Lake Crescent 50mm f/16 15s ISO400

Time	Best Good							Reward	*		

Budget	30-45 min	Type	Out & Back	Effort					

RT Distance	~0.1 mi	Δ Elev.	<30 ft	Zoom	Norm, Tele

Salmon Cascades handily earns its 3 Wow's from late September through October, when salmon swim upriver to spawn. The asterisk (*) is relative to witnessing this... Without the salmon, the waterfall would likely earn only 1 Wow.

The exhibit is well-marked off Sol Duc Hot Springs Road. (Do not mistake a riverview picnic area prior to this, if coming up from Highway 101.) At the Salmon Cascades parking area there is a vault toilet and a short trail to a viewing platform. Unfortunately the viewing platform does not provide the right perspective for photography. At time of writing, there is a permitted route to the right of the viewing platform that will allow for a better angle atop large rocks of the main fall and the salmon leaping from the river. (Likely you will see other people there too.) **Proceed cautiously; you do NOT need to position yourself close to any rock's edge for a workable angle. The rocks are slippery.**

Assuming the salmon are "running," your first order of business is to simply study their route and routine. Using a tripod, frame the falls and where you *think* a salmon will emerge... I set up my camera on manual mode – aperture, shutter speed, ISO, and even switch from autofocus to manual (once I have focus achieved). I also set the camera to fire a continuous burst of shots.

Watch their approach beneath the water's surface, as best you can, and once you sense their jump from the water, capture as many frames as your camera will allow. (Presetting the camera, as mentioned above, better allows the camera to work its fastest, without having to waste precious milliseconds "thinking.")

There is a rhythm to this exercise. After some initial attempts and adjustments I expect your captures to improve in quality... This has been my experience.

Regarding camera settings, some compromises will have to be made... The foundation should be a shutter speed of *at least* 1/1000s. Next is aperture, because you will need some depth of field, since you won't know exactly how close or far the salmon will be from where you set focus. (Hint: "Perfect" focus should be set slightly in front of the waterfall, not on it... Though this may only matter in practice for telephoto focal lengths.) Back to aperture... I recommend between f/4 and f/5.6. These settings will then dictate ISO.

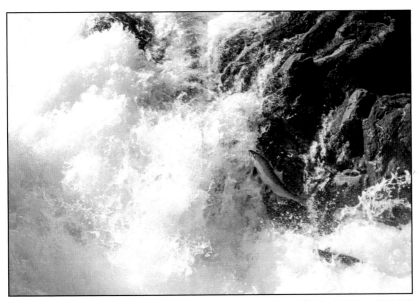

Making a Jump for It 70mm f/4.5 1/1600s ISO400

To the left of the viewing platform is another informal route, this time upriver. It leads to some broad and somewhat level rocks along the river bank. If looking for a "capture" of the Sol Duc River, this is a good place. It can also be a good location for a self portrait or a photo of your entourage. This is from where my portrait was taken on page 138 on a typical, rainy day (and not during a salmon run). Ha!

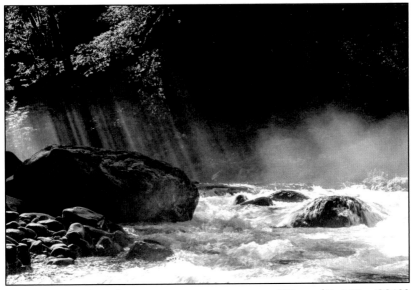

Sun & Mist along the Sol Duc River 100mm f/8 1/30s ISO100

Time	Best Good		Reward		
Budget	45-60 min	Type	Lollipop Loop	Effort	
RT Distance	~0.5 mi	Δ Elev.	~60 ft	Zoom	Normal

Hopefully if you're making the drive up Sol Duc you will hike Sol Duc Falls (23). It's one of the best hikes in this book. I believe that the Ancient Groves Nature Trail compliments it nicely. Its "character" changes a bit from season to season, so I've found myself stopping by and hiking it on numerous occasions. It's simple, but pleasant. Do not let its 2 Wow's discourage you from checking it out.

There are two pullouts about ¼ mile apart along Sol Duc Hot Springs Road for parking. You can park and access the loop trail at either location. Just remember which one you parked at... On my first visit I didn't know this and when I emerged I thought my truck was stolen!

Enjoy the little ups and downs along the trail as it swerves and make a loop. At its far side the route skirts an edge high above the Sol Duc River. There is also a small wetland where Skunk Cabbage grows.

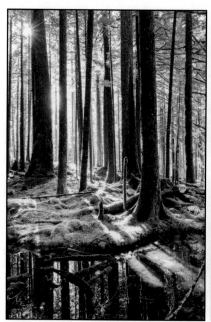

35mm f/2.8 1/60s ISO800

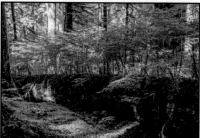

24mm f/11 1/10s ISO1600　　　　70mm f/5.6 1/20s ISO800

I have tried this loop in early morning light, and it's a bit dull. The late afternoon light is the very best, if your schedule will allow. Perhaps, if staying at the resort, you can come by prior to dinner.

Time	Best Good									Reward ✹ ✹ ✹ ✹
Budget	1-2 hr		Type	Out & Back						Effort 🥾 🥾 **🥾 🥾 🥾**
RT Distance ~1.6 mi			Δ Elev.	~200 ft						Zoom Wide, Norm

The trail to Sol Duc Falls is my go-to recommendation when asked by others for a memorable and straightforward hike that captures the essence of Olympic National Park. For visiting photographers, I consider it a **must do**. I was overjoyed when one of the falls' compositions fit the necessary "format" of my book covers.

You might not know it, but there's another spectacular subject along the way. (More great news!) Halfway to the falls the trail crosses this unnamed creek with an abundance of moss-covered rocks and logs. This photo (below) is hanging on my wall at my left, as I write.

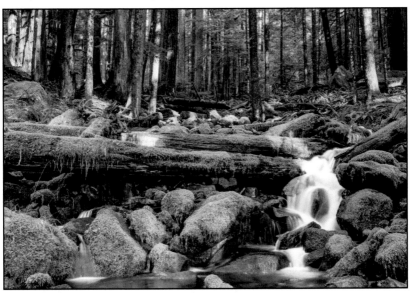

En Route to Sol Duc Falls 35mm f/16 4s ISO200

One more thing, before diving into the trail and photography details... **Sol Duc Falls produces abundant mist in the areas you will be capturing images. Your camera and body will get wet.** If your camera is not suitable for wet conditions, seek means to cover the camera and lens with a purpose-made cover or bags or something. As for clothes, I usually bring along a rain jacket just for while I'm at the falls.

The trailhead and its parking lot are at the end of Sol Duc Hot Springs Road. The route begins downhill a bit before returning the favor with some moderate climbing. (It's not much.) My GPS results along this

route have been inconsistent over the years (to say the least), so do not consider mileages here to be that reliable. All that said, at about 0.4 mile reach a foot bridge over the aforementioned, unnamed creek. From the bridge's vantage, it looks good, but admittedly not as good as on the prior page. This is because the best of the mossy rocks and logs are upstream a bit. So, on the opposite side of the bridge (or the side if you were to continue to Sol Duc Falls) find an informal route uphill. It is up a ways – about 100 feet or so. You'll know it when you see it. My shot was taken one late November afternoon.

Back on the main trail... As you near the falls, on the left is a log shelter. Have a quick look. Once ready, continue the final descent to the bridge over the Sol Duc River, with Sol Duc Falls in sight. Time to don your wet weather wear and ready your camera for the mist!

There are two "main" compositions to be made of the falls. The first is from on the bridge. This is the composition at right. The second is from the viewing area in front of the falls. This one is a little more tricky, as camera positioning is perhaps a little more critical. This is the composition on the book cover. As always, try various compositions.

On sunny days in the late afternoon it is possible to capture a rainbow from the bridge area. Where you position yourself will dictate the rainbow's orientation (and of course the relativity to the sun behind you). The gist, though, is that you can relocate your camera to achieve different rainbow results. For the most vivid colors with a rainbow a polarizer helps. But... There is a fine line with rainbows and polarizers. You can over-polarize and the rainbow dims, so do experiment.

Another rainbow option is to begin up the trail to the right once on the other side of the bridge. This trail is known as Lover's Lane. It immediately ascends, and with that change in elevation the rainbow's position and intensity may improve for your composition.

Some "seasonal" commentary... During springtime the prolific Devil's Club (plant) around the falls is dense and a colorful green. It remains into the summer, but it loses some of its deep green. During fall its large leaves drop. Fall adds some usual foliage color, but it is not much. Winter is the most "drab," and while I have not been here with snowfall, it would likely add its own unique twist. Now compare the cover photo with this one at right. The biggest difference (besides the rainbow!) is the presence of Devil's Club on the cover photo. I just want you to be aware of the differences, no matter when you visit. Anytime of the year this site is always great.

Once finished, dry off and prepare for the hike back. If your scheduling and timing is on point, consider a soak in the hot springs at the resort... That's one heck of a grand way to finish a day!

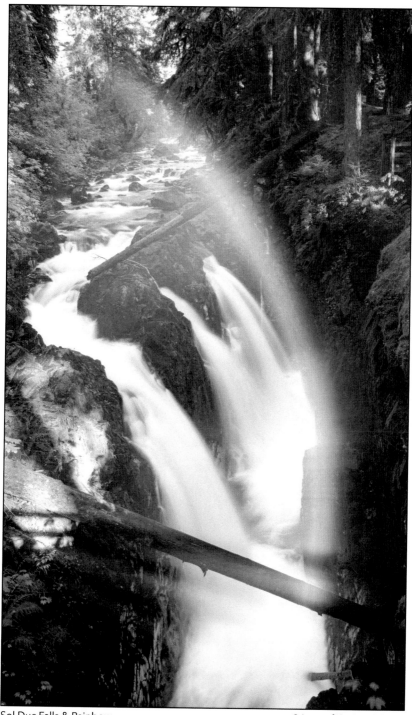

Sol Duc Falls & Rainbow

24mm f/8 1s ISO100

Time	Best Good	☼	☼	☼	☼	◐	Reward ✺ ✺ ✺ ✺

Budget	15-45 min	Type	Varies	Effort 🏋 🏋 🏋 🏋 🏋

RT Distance	<500 ft	Δ Elev.	<30 ft	Zoom	Wide, Norm

Here we're going to explore a few options in and around Fairholme, which is on the west end of Lake Crescent.

Right off Highway 101 find Camp David Jr. Road... It is only modestly marked with a typical green street sign. (If you are eastbound and reach the Fairholme General Store you just missed it.) Upon turning onto Camp David Jr. Road, almost immediately find the turn-in for the boat launch and beach area on your right.

As you make your way in, ahead you will spot a whimsically-shaped, *enormous* maple. Once I discovered this tree, it alone had me coming back to this location regularly. It is a bit entrancing on its own or for a family and friends photo. I call it the "Fairholme Maple."

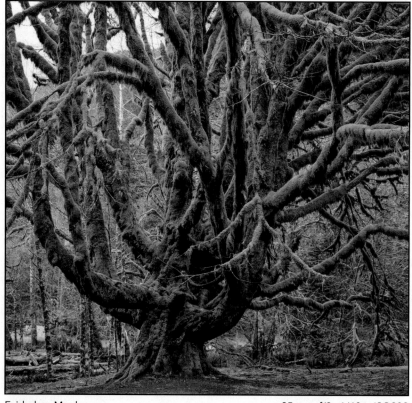

Fairholme Maple 35mm f/2 1/60s ISO200

Also at this beach in the warmest months you will find many people kayaking and canoeing. Many of these canoes and kayaks are colorful and can provide for a foreground or middle-of-the-frame interest that compliments the lake view to the east. This is, of course, a daytime option. If looking for a sunrise location this spot can be OK (and it is entirely easy), but a better view is down the road a bit...

Back on Camp David Jr. Road, the North Shore Picnic Area is about 3.2 miles further. (The last ~1.5 miles is unpaved.) There are two parking areas – one is roadside, and the other is accessed just after a right turn down into the forest a bit. If arriving for sunrise, bring a light to illuminate the way to a picnic table-adorned dock.

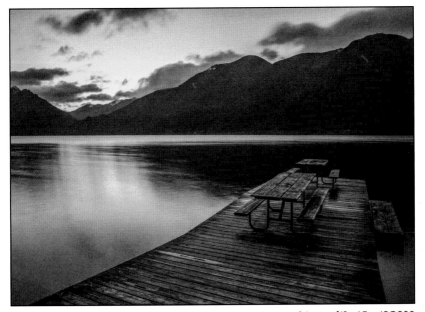

North Shore Picnic Area 24mm f/8 15s ISO200

I have never seen such a small dock set up primarily for the purpose of picnicking. For us, the location and arrangement are ideal, as you can frame the scene westerly, for the colorful sky and its reflection on the lake.

Above I used a 24mm focal length, but while there I wish I had something a bit wider – maybe 18mm or 20mm. It would have allowed me to remain closer to the tables and still capture the "width" of the lake and sky that I desired for color. Regardless of the focal length, consider a slower shutter speed to help calm the early morning lake water. (Though some mornings it is entirely calm on its own.) Some significant dodging (or shadows "illumination") likely will be required during post-processing for improved exposure of the dock and tables.

Time	Best Good								Reward			
Budget	30-90 min		**Type**		Varies		**Effort**					
RT Distance <1.0 mi			**Δ Elev.**		<20 ft		**Zoom**		Whole Kit!			

There's no reason *not* to stop by and explore the Lake Crescent Lodge and the greater **Barnes Point** area.

The lodge was built in 1916, and it is in my opinion a wisely delicate architecture on the serene Lake Crescent. It hosts accommodations in both the lodge and adjoining cottages (cabins) and more modern multi-level facilities. Dining at the lodge is magnificent, but sometimes wait times can be long. If you have time, I encourage a lunch here.

Stroll the grounds, and be sure to walk out onto the dock in front of the lodge. This is the best place for a photograph of the historic building.

Beyond the lodge, a short walking distance to the northeast is the **Moments in Time Interpretive Trail**. This is a simple and short **must do** if having stopped in this area. My recommendation is to walk in a clockwise direction, from the lodge area, towards NatureBridge, and then back towards the lodge to finish.

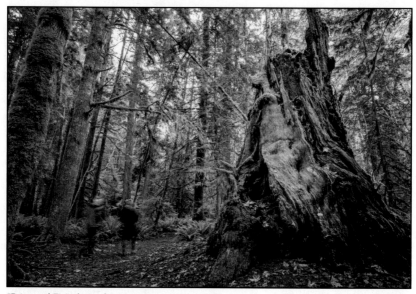

"Primeval Fir" along the Moments in Time Trail 20mm f/5.6 0.6s ISO200

NatureBridge is an organization (and physical campus) that hosts a variety of nature conservatism events, classes, and students. If strolling their grounds, please realize some of the dwellings may be occupied.

Time Best Good	Reward

Budget	1-1.5 hr	Type	Lollipop Loop	Effort	
RT Distance	~1.8 mi	Δ Elev.	~400 ft	Zoom	Normal

Visiting Marymere Falls is as much about the hike as it is the destination. If it were a roadside waterfall it would probably only earn 2 Wow's. But, it's not... The trail there is interesting, with two creek crossings over photogenic bridges.

The trail begins at the Storm King Ranger Station on Barnes Point, via the same network of roads off Highway 101 to the Lake Crescent Lodge. Turn right towards the ranger station off of Lake Crescent Road.

Interesting – after briefly paralleling the parking lot, the trail goes *under* Highway 101 through a clever pedestrian tunnel. If you are visiting during the summer, especially a summer weekend day, this will likely be your first witness of just how crowded this trail becomes at times. (Perhaps though your second witness, if parking was problematic.) Many people day trip to this area to visit the Lake Crescent Lodge and make the hike to Marymere Falls. Your best defense is a good offense; if you can, plan for a visit in the early morning or late afternoon.

The trail continues through the forest with minimal elevation gain. At ~0.5 mile find an intersection for the trail serving Mount Storm King (27) at your left. Continue straight, and after another ~0.2 mile reach Barnes Creek and its bridge. The "beach" adjacent to Barnes Creek is easily accessible and is a good place for photos of both bridges and creeks. (Spot the log-style bridge over Falls Creek to the right.)

After crossing Barnes Creek the second bridge comes quickly; this is the one over Falls Creek. (This is the water flow downstream of Marymere Falls.) After this bridge it is time to climb.

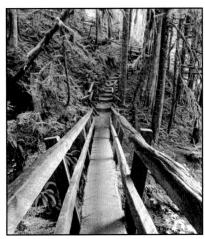

A small loop provides access to two viewing areas. Turn left to go clockwise to the lower viewing area first. It is the better of the two, with unobstructed visibility of the waterfall.

My favorite photos of Marymere

35mm f/4 1/30s ISO1600

Falls are not of the waterfall as a whole, but zoomed-in a bit capturing its whispy details. When doing so, I use a focal length of about 100mm, and I slow the shutter speed to less than 1 second. The area is typically shaded, so manipulating ISO and aperture is usually enough. (A neutral density filter is not required.)

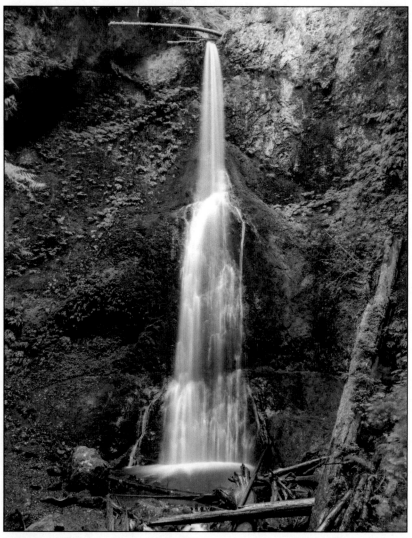

Marymere Falls 28mm f/11 4s ISO100

Once ready, if interested in seeing the upper viewing area, climb the steep and wet stairs behind you. Otherwise turn around and head back down. (As implied before, its visibility of the falls is not great from up higher, so if crowds have you down or if you are just ready to head back, skip it and use your time elsewhere.)

Wait, what's this? This wasn't in the Table of Contents!

I scatter these throughout my books, usually two or three per volume... Offbeat topics, usually that can apply anywhere – maybe even beyond this national park. They're "just for fun."

Landscapes are clearly my primary interest, though while at national parks it's instinctive to also enjoy the area's unique wildlife and architecture too. I believe that serious wildlife photography is quite a specialized endeavor, and why I choose to minimally cover it in these books. (I digress.) Architecture in national parks, however, is easily accessed, usually historic, and adds to our landscape endeavors.

Ranger stations often make for fun subjects, and I like photographing them. Having visited the Storm King Ranger Station multiple times, I just wasn't ever happy with the "end result" of either my compositions of it or my post-processing. Usually when this happens, I try something different. Here, while post-processing I applied a "vintage" film preset and refined its character further until I was satisfied.

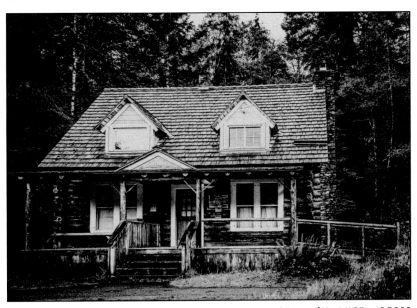

Storm King Ranger Station 35mm f/4 1/125s ISO200

I also enjoy black and white photos, but to me Olympic National Park compositions seem to more often display best in full color. But, this is an option too, if you're looking for another kind of post-processing "change of pace" with a particular photo.

Time	Best Good		Reward		
Budget	3.5-4.5 hr	Type	Out & Back	Effort	
RT Distance	~4.2 mi	Δ Elev.	~2,000 ft	Zoom	Wide Angle

The view of Lake Crescent from Mount Storm King is without doubt **the best bird's eye view in Olympic National Park**. The catch? The last ¼ mile requires ropes in areas to ascend the steep and loose grade to the top. A fall anywhere along this final stint could result in serious injury, if not loss of life. Further detail is provided; read on to gauge your interest and capability to hike this route.

Before detailing the hike and what to expect, I want to share my recommendations on what to take along, beyond the hiking "10 essentials." First and foremost, hiking **shoes or boots that provide good traction on loose dirt and rock**. The soles of your footwear should have a rugged pattern for good grip. As for camera gear, I recommend to travel with your camera and **wide angle lens only** to keep your weight down. A tripod likely won't be necessary if shooting in daylight conditions. Lastly, pack **leather gloves** for the ropes work and also for steadying yourself on rocks.

Like the hike to Marymere Falls (26), the trail begins at the Storm King Ranger Station. As mentioned in that narrative, at ~0.5 mile find a well-marked left turn to Mount Storm King. The climbing begins immediately. Good news to some, bad news to others, the grade from here to the top remains more or less constant the entire way.

Somewhere between 0.8-0.9 mile the trail passes through a pleasant, lush green space in the forest. Some nice compositions are possible here, and this spot makes for a good place for a break.

Reach ~1.6 miles, and on most warm days this hard right bend in the trail will provide a refreshing, cool rush of air. (On cold days it's frigid.) Some peekaboo views of the lake are present along the route after this bend, but they take a distant 2nd place to what's in store a the top.

Reach a sign declaring an end of the maintained trail at about 1.8 miles. You will see ahead that the landscape changes significantly. This is a good time to don your gloves.

At ~1.9 miles is the first set of ropes. I have lost count – I believe there are either 4 or 5 sections of rope to the top. All your gear should be stowed so that both your hands are free to grip the rope, one hand over the other, as you ascend (and later descend). You are still walking with your feet, but your hands and arms will aid in the climb (and exit descent afterwards).

The ropes can become busy at times. You may need to wait your turn for others going up or down. Once finished with the ropes, the final approach is up and over exposed rocks.

 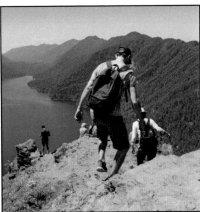

My favorite spot for a sweeping photograph of Lake Crescent is near the front of this area, so that some foreground elements may be captured in the composition as well. Wildflowers are sparse here, but do grow. Be careful not to position yourself too close to any edge, for your sake and for your equipment's sake, if you were to drop something or lose your balance.

Lake Crescent from Mount Storm King 24mm f/5.6 1/60s ISO100

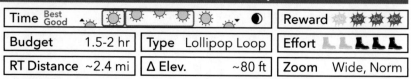

Time	Best Good		Reward		
Budget	1.5-2 hr	Type	Lollipop Loop	Effort	
RT Distance	~2.4 mi	Δ Elev.	~80 ft	Zoom	Wide, Norm

A World War I era construction, the Spruce Railroad Grade was originally conceived for the transportation of Sitka Spruce timber in warplane manufacturing, but the war concluded before it was put to use. Later the grade was utilized for commercial purposes, but its service only lasted a few decades before becoming abandoned. Today we have the "Spruce Railroad Trail," renovated for recreational use along the north shore of Lake Crescent.

Its route is along a wide, paved path. Most visitors walk the route, though cycling and horseback riding are permitted. I have both walked the route and bicycled on it... Both are enjoyable. The one, obvious advantage to cycling is that the distance can be covered in far less time. However, if cycling, to access **Devil's Punchbowl** you will have to walk your bicycle about ¼ mile in total.

Part of the much larger **Olympic Discovery Trail**, the Spruce Railroad Trail has access points on its northeast end off East Beach Road (~4.1 miles from Highway 101) and on its west end off Camp David Jr. Road. Its best parts are closer to the East Beach Road end, with ample parking, and I will be covering it as such here. The "destination," or turn-around for us is at Devil's Punchbowl and the adjacent McPhee Tunnel. Another, shorter (and less interesting) tunnel, the Daley Rankin Tunnel, is about 1.6 miles further west.

From the East Beach Road parking area, the trail climbs immediately, gaining about 60 feet in elevation. It peaks and then drops about 80 feet to near lake level and remains at this elevation, more or less, to our feature destinations. At ~1.0 mile come upon the McPhee Tunnel. My recommendation is to save the tunnel exploration until after first visiting Devil's Punchbowl. (So this will be a clockwise loop, finishing by exiting the tunnel to where you are now.)

Find an unpaved trail to the left of the tunnel, and hike to Devil's Punchbowl. This section of trail is between 0.1-0.2 mile long.

Devil's Punchbowl is a popular place for swimming in the summertime. While I recommend a middle-of-the-day visit for most vivid water color, it can be busy if the weather is hot – especially weekends. So consider the seasonal impact... If summertime and hot when swimmers likely will be present, consider visiting in the morning for lighter crowds. Any other season, middle of the day is ideal.

Devil's Punchbowl 15mm f/4 1/125s ISO100

Once having explored the area, continue along the trail (this side a bit shorter than the first). Exit, back onto the railroad grade, now at the opposite end of the McPhee Tunnel.

The tunnel is only about 0.1 mile long. It is curved a bit, so while when you enter it appears without any light, almost immediately upon walking your eyes will adjust and you'll see light entering from the opposite end. Admittedly, the tunnel is more "fun" than photogenic.

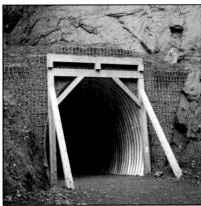

35mm f/2.8 1/10s ISO3200 (+ light) 50mm f/3.5 1/100s ISO200

And that's it. Head on back to the parking area the same way you came.

Time	Best Good								Reward			
Budget	15-30 min		Type		Out & Back				Effort			
RT Distance	~0.2 mi		Δ Elev.		~20 ft				Zoom		Normal	

Due to the washout of Olympic Hot Springs Road, Madison Falls is at the time of writing the *only* drive-to site in the Elwha Valley. The road is closed just beyond the parking area for the falls. Across the road from the parking area is a nice view of the Elwha River.

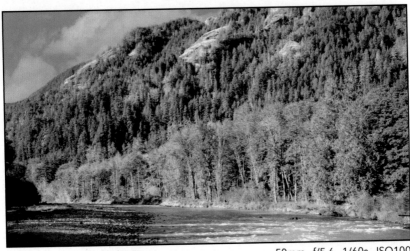

Fall Color along the Elwha River 50mm f/5.6 1/60s ISO100

The trail to the falls is paved and short. In the fall Bigleaf Maples color this area in pleasant shades of yellow and orange. (A bonus feature if visiting while the leaves are changing.)

After the brief walk, you will find a viewing area that is suitable for quick and easy photography. The issue here, much like at Marymere Falls (26) is lack of foreground "presence" from this vantage.

Though unlike Marymere Falls, it is practical to navigate down towards the creek for an improved perspective. The composition at right was made from *within* Madison Creek. (Hence the 2-Boot rating.)

Which leads me to a topic I think worth discussing... Just what constitutes "off limits" exploration? My mission as an author is to not send you anywhere that the National Park Service considers out of bounds, whether it be for conservation, reconstruction, safety, or otherwise. If any new, official national park signage dictates this area off limits, then photography from the viewing area may only be possible. Hopefully though, this doesn't become the case here.

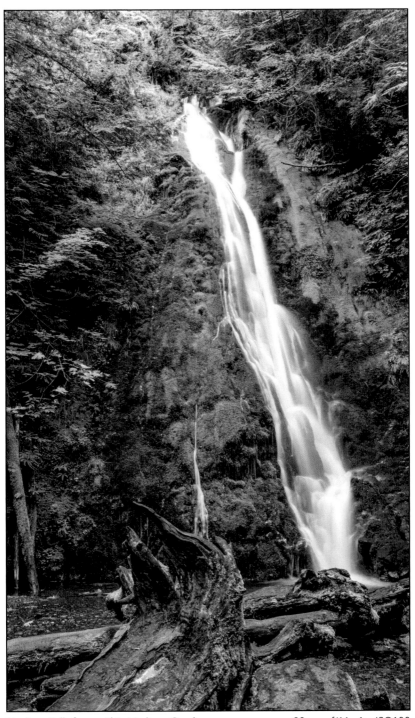

Madison Falls from within Madison Creek

28mm f/11 4s ISO100

Time Best Good		Reward
Budget 4.5-5.5 hr	**Type** Out & Back	**Effort**
RT Distance ~7.4 mi	**Δ Elev.** ~900 ft	**Zoom** Normal

Between 2011-2014 the National Park Service oversaw the removal of two dams on the Elwha River in order to return unfettered access to salmon to this delicate ecosystem. Other fauna and flora had been significantly impacted by the salmon's diminutive population with the dams in place, and they are now also once again thriving, thanks to the salmon's return.

After demolition was completed of the Glines Canyon Dam, the larger of the two dams along this river, viewing platforms were created for visitors to witness this ecological regrowth along the Elwha River Valley. The dam stood at over 200 feet tall, and as you would expect the views atop the existing spillway are impressive. *Of note, there are viewing platforms on both sides of where the dam once was. Not covered is the smaller one on the east side of the river, off Whiskey Bend Road. This narrative covers the "main" one on the west side of the river, off Olympic Hot Springs Road.* Along this viewing platform are insightful information boards and exhibits, outlining the area's past and what to expect in the near future as the ecosystem recovers.

For the sake of continuity the Budget and Effort categories above are as if you are to walk the entire length. Much of the route is along the paved Olympic Hot Springs Road. My preference, rather, is to bicycle this route, if you have the means. If bicycling, you could expect to shave ~90 minutes off the duration. There is one trail that is not suitable for cycling, so on that section you would need to walk your bike (uphill and downhill over typical "hiking" terrain). If this is of interest, read closely the discussion about the "Bypass Trail" and its characteristics.

Parking is the same as for Madison Falls (29). Before starting, study the abundant information on the boards near the gate. I recommend taking pictures of the maps for possible later reference.

The road is your route. At about 0.6 mile find good signage directing you into the forest on the Bypass Trail. **This is the only safe route around the washed-out road. If you see other trails, they are to be avoided.** If you are curious what the first washout looks like and there is not signage restricting passage, it is another ~0.3 mile further. (The ~0.6 mile round trip effort [in order to return to the Bypass Trail entrance] takes between 15-20 minutes if walking.) The potential strength of this river can be easily envisioned when seeing the damage firsthand.

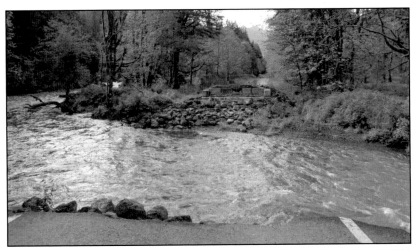

Triumphant River 28mm f/8 1/200s ISO200

The **Bypass Trail** is a typical, forested hiking trail over soil and rocks. It climbs ~200 feet over ~0.3 mile to its highest point at an intersection with the Cascade Rock Trail. It then descends the same ~200 feet over ~0.5 mile, exiting onto Olympic Hot Springs Road (upriver of the two, washed-out sections).

Here the on-pavement journey resumes. My favorite season here is the fall, as there is abundant color along this route, providing much-needed interest while walking along on the road.

Autumn Iridescent Vine Maple 100mm f/4 1/100s ISO800

At ~1.8 miles pass the quaint Elwha Ranger Station, and then soon after the turnoff to Whiskey Bend Road. (Stay straight on Olympic Hot Springs Road.) Cross the river via bridge... If the water is clear enough, look for salmon and trout below. The Altair Picnic Area turnoff is next at ~2.2 miles, followed by a steeper ascent towards the dam.

Just before the dam, take note of a turnoff at the left with a double gate... I recommend exploring this on the way back down and will explain further in a moment.

At ~3.4 miles, reach the Glines Canyon Dam Overlook and its accompanying parking area. "Park" your backpack and/or your bicycle perhaps, and go explore the renovated spillway and its abundant exhibits.

From the furthest point on the spillway find a sweeping view south to where the Lake Mills reservoir once occupied a vast space, now in a period of rapid regrowth. Also at various other places along the spillway peer down, as the river water rushes through Glines Canyon. I also enjoy the mechanical elements of the existing spillway gates, especially the witness of primer and paint over its concrete during a presumably-long ago maintenance effort.

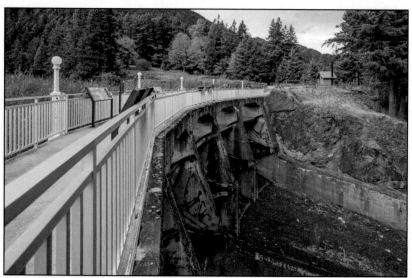

Glines Canyon Dam Spillway 24mm f/5.6 1/250s ISO200

Find the exhibit titled "Powering the Past." On its right side is an illustration of the entire network of facilities that once made up the dam. The powerhouse location was down that gated road mentioned above. It is worth the short detour once you are satisfied with your visit at the overlook and its surrounding area. So when ready, head on out.

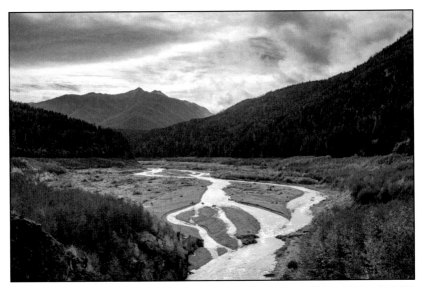

Lake Mills Area Restoration 28mm f/5.6 1/320s ISO100

Back down Olympic Hot Springs Road and if electing to check out the former powerhouse location, once through the gate it is not quite 0.2 mile to the river's edge. This had been a kayak launch (and may still be), as with the dam in place it was the furthest upriver someone could access. Today, with the powerhouse gone, access to near the water's edge is possible by hiking down and over a plethora of small rocks to the right.

This is a sensational and up-close view of the Elwha River after it completes its final bend through Glines Canyon. The water color is a rich teal that compliments the other colors in view. Even though there is only one scene, varying between landscape and portrait orientations, wider to longer focal lengths, and fast to slow shutter speeds provides the photographer with a variety of interesting compositions.

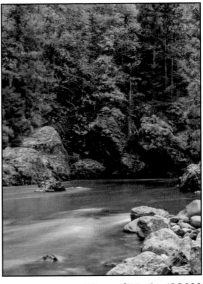

The route back is mostly downhill, with the exception of the climb along the Bypass Trail. This abundant descent is where a bicycle really speeds things up.

35mm f/16 2s ISO200

Time	Best Good		Reward		
Budget	1-2 hr	Type	Out & Back	Effort	
RT Distance	<0.7 mi	Δ Elev.	<30 ft	Zoom	Norm, Tele

Use the **Crescent Bay** tide station for planning.

This is way off the "Olympic National Park beaten path," but I wouldn't recommend you visit unless it is totally worth it. And it is.

Tongue Point is only intended as a tide pools destination. So while there are "Best" and "Good" times to be there due to lighting, the ONLY time to be there for our purpose is during a low tide, so hopefully this seawater level will occur during daytime hours while you are in the area. The advice on page 33 applies, and the lower the tide the better. **Of all the tide pools areas I have visited on the Olympic Peninsula, this one is hands down** *the best.*

Tongue Point is located in the Salt Creek Recreation Area, a Clallum County public park. Great news – at time of writing, access is free! If driving from Port Angeles it is about 15 miles or 25 minutes.

Roads within the Salt Creek Recreation Area are plentiful, as it is sizable and has many outdoor activities. Assistance from your preferred mapping app will help. Basically, follow signage to the campground (not the RV sites) and to Tongue Point. Once within the campground, two parking areas are available, each next to large, marine life information boards. One is adjacent to campsite 63; the other is adjacent to campsite 67. (If you can choose between the two, park next to 67, as the walk to Tongue Point is more direct.)

Make your way down to the water... Wow, navigating this area requires some agility, hence the 4 Boots rating. I would venture to say that most people can do it, but some will require more time doing so than others.

The "best" of the tide pools are on the right side (east side of the point). Also as suggested on page 33, safely make your way as far out to the water's edge as possible for the most exposed tide pools. That said, some deeper and interesting ones may be a little further "inland" than at the water's edge. Resist the desire to not devote too much time checking everything out on your approach. Work first out, then work back.

Final advice – unless you're just entirely weary of crowds, if you see an assembly of people checking out something, go have a look. There are some relatively rare lifeforms here. Someone that knows something may have spotted something not to be missed!

250mm f/4 1/100s ISO100

100mm f/5.6 1/10s ISO200

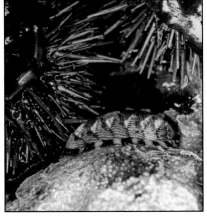

300mm f/6.3 1/13s ISO200

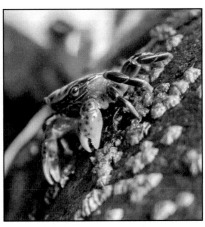

400mm f/5.6 1/160s ISO800

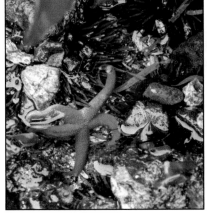

150mm f/5.6 1/15s ISO400

100mm f/4 1/60s ISO400

Time	Best		Reward		
Budget	30-45 min	Type	Roadside	Effort	
RT Distance	<200 ft	Δ Elev.	<10 ft	Zoom	Wide Angle

I think these are always fun – to look at, and to photograph – and I usually seek-out places in national parks where the effect translates well within a photo.

Here, we have a pretty unique topic, so I'll lay-out an abundance of pointers specific to this activity.

But let's address the "where" question first. My rule of thumb is that you're composing for 3 key features at minimum here – a car's tail light "trails," the starry night sky, and then something interesting that captures "where you are." Obviously for the shot on the following page, I selected a tunnel – this is the middle one (of three) on Hurricane Ridge Road. This is its southwest / downhill entrance.

Some other spots that would also work... From a pullout on Highway 101 along Lake Crescent's south shore or the Hood Canal's west shore. Underneath a canopy of trees alongside Sol Duc Hot Springs Road.

OK, so now that we have a few location options at your disposal, let's tackle the technical how-to, from primary setup to final camera adjustments. (All photographers know the one truth about "rules" in photography are that they're meant to be broken, so please think of all the following as guidelines or starting points. Experimentation is encouraged!)

Assuming you are roadside (to your subject vehicle or vehicles), work in the direction that permits capturing the passing car's tail lights. The issue with headlights, is that from this vantage, the bright light will illuminate the inside of your lens and in essence totally wash-out your exposure. Plus, the passing car will aid in your overall light capture by "painting" the roadway (and roadside features) with light.

Some sort of rigid camera support is mandatory. I recommend a tripod. A headlamp or flashlight also helps immensely.

Lens selection... If you have the option, a fast wide angle is best. By "fast," I mean f/1.4-f/2.8. And by wide angle, 35mm or wider. You can use a slower lens, it just means there will be some compromises to ISO and shutter speed. And lenses with longer reach than 35mm will begin to struggle with depth of field and capturing the whole scene. This is all a bit subjective, so if you have multiple lens options, try each of them out, and learn their strengths and weaknesses for this work.

Downhill on Hurricane Ridge Road 24mm f/2.8 20s ISO400

Here, perhaps, is the hardest part... You're going to need to manually focus your lens to infinity and leave it there. Leaving autofocus turned on is the best way to a very frustrating evening. It just won't work. So, illuminate something in the distance, lock-in focus, and leave it there. (Hopefully your lens has a focus window, and if it does check the lens' setting occasionally, to ensure it hasn't moved.) Warning!: If you are using a zoom lens for this, you cannot zoom in or out after you have set focus. Focus is only set for a particular focal length. So if you're using a zoom, be careful of this as well.

Alright, we're getting close... Compose your shot, as best you can. (This can be difficult sometimes, depending on how dark it is.) If after you take some shots, you can make some alignment and positioning adjustments.

Set your camera body to Manual mode, and now we need a starting point... The following table lists some options.

Aperture	f/1.4	f/1.8 or f/2	f/2.8	f/3.5 or f/4
ISO	100	200	400	800
Shutter Speed	15 sec	15 sec	15 sec	15 sec

You're ready to go. Now, using either a timer or a remote shutter release, listen for an approaching car, begin your exposure, and wait to see what happens! Take a look at your screen, and adjust accordingly.

Generally, you want to keep your ISO as low as possible, to minimize noise. Those of you with faster lenses (f/1.4 to f/2, for example), may find that you need to stop down to f/2.8 for depth of field (focus throughout your frame). Adjust the shutter speed (8 to 30 seconds) to suit your needs.

That's basically it. Be careful, good luck, and have fun!

Oh wait, there's more good news! This same technique works well for photographing the Milky Way. The very short summer nights at Olympic National Park make capturing it a bit challenging, but if you're timing is right Hurricane Ridge (33) is a great place for a composition. The below was taken in early July at about midnight.

Olympic Mountains and the Milky Way 24mm f/2.8 25s ISO6400

Time	Best Good									Reward	✺ ✺ ✺ ✺

Budget	1-3 hr	Type	Varies	Effort	👢 👢 👢 👢 👢
RT Distance	<1.5 mi	Δ Elev.	<300 ft	Zoom	Norm, Tele

Amazing – this is the one site where *anytime* of day qualifies as "Best" or "Good." I could have boxed nighttime too, but nighttime visits are calendar-specific (Milky Way, moon, etc), so I didn't. Though the photo on the opposite page sure had me thinking otherwise!

Hurricane Ridge is most visitors' "one stop shop" for the Olympic National Park mountain experience. It might as well be – it's the only *paved* road in the park offering high elevation, unobstructed mountain views. During summer weekends, it can become crowded, with parking becoming somewhat of a challenge. If your travel plans require a summer weekend visit, plan to arrive early or late in the day.

Of critical note – if you visit when Hurricane Ridge Road is routinely closed and opened due to snow and ice conditions, it is not open around the clock. The National Park Service will typically open the access gate near Heart O' the Hills at 9am (some days 8am) and closes the gate at 5pm. You must be through the gate before it closes! Translation: sunrise and sunset work is not an option during this time.

First Light on Mount Olympus 300mm f/5.6 1/250s ISO400

Quickly, regarding sunrise (as you'll be arriving somewhat in the dark), my advice is to park in one of the first spots available at your left (on the east end of the lot). From here you can find the sweet spot where

some trees downhill to your left do not obstruct the valley view and you still have good framing looking westerly. A sunrise "bonus" is when there are low clouds in the valley below. This is neat.

The visitor center is ahead on the left and a few, short trails are to the right. It doesn't take much time or effort to explore the paved Big Meadow Loop and Cirque Rim Trails. Views are good, but not great, though deer frequenting the area and summer wildflowers can provide additional interest.

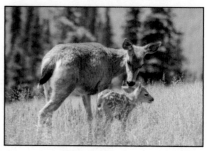

400mm f/5.6 1/500s ISO400

Beyond these parking lot-level views, which do not take much time to explore, my favorite is the hike to Sunrise Point and back. From the east end of the parking lot find the paved access to the far end of the Cirque Rim Trail. Follow it, and after ~300 ft is a trail to the right, the east side of the High Ridge Trail loop. Follow this route. It begins to climb, and pavement turns to dirt in short order. Between 0.3-0.4 mile is another intersection... To the right is the Klahhane Ridge Trail – do not take this. Stay straight along the exposed ridge to the end, which is Sunrise Point.

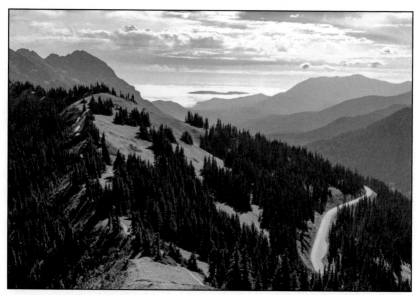

Northeast View from Sunrise Point 40mm f/8 1/400s ISO100

Here, we can look northeast to the Strait of Juan de Fuca, though cloud cover may dictate how clear the view is!

Once finished at Sunrise Point, backtrack along the ridge to the first trail intersection. This time, veer right to hike beneath the trees along the west side of the High Ridge Trail loop. This is an enjoyable section of trail, as it zigzags and descends under a canopy of trees to its finale, ending along the Cirque Rim Trail again. This loop hike, from the parking lot to Sunrise Point and back (as prescribed), is about 0.9 mile in length with ~200 feet of elevation gain.

Do be sure to explore the visitor center's back patio facing Mount Olympus. The information boards here are insightful, and other photo opportunities are possible. Deer graze on the grass here as well, and with some luck and good framing it is possible to capture them in the meadow with the mountains in the distance.

Inside the visitor center is a large, 3D map of the Olympic Peninsula, including many Olympic National Park waypoints. Also inside the visitor center is a "library" of wildflower samples and names, contained in a wooden, interactive display case. For the wildflower aficionados, this is a handy tool! ...On the topic of wildflowers, while they do bloom in mid- to late summer, I have never found them to be as abundant as in Mount Rainier National Park. I would say that the wildflowers in Olympic National Park are a bit "patchy." (Some flower humor.) In all seriousness, while they can appear somewhat abundant to the naked eye in places, they typically are too sparse for good subject matter in photos. My best experiences have been along the hike to Hurricane Hill (34) and along Obstruction Point Road (35).

Beyond the large parking lot, Hurricane Ridge Road continues west to two picnic areas and finally to Hurricane Hill. These picnic areas are absolutely fantastic, and if you are either looking for alternative parking options or a place for a meal or snack, I highly recommend them. The road does descend a bit as you travel west, away from the visitor center area, and it is curvy... If walking alongside it, be careful. If driving, take it slow and give pedestrians space.

Winter View along the Cirque Rim Trail 35mm f/8 1/320s ISO100

Time	Best Good	...							Reward				

Budget	2-3 hr	Type	Out & Back	Effort	

RT Distance	~3.2 mi	Δ Elev.	~740 ft	Zoom	Norm, Tele

If a longer hike is desired in the greater Hurricane Ridge area, Hurricane Hill is your ticket. It provides an interesting terrain with sweeping views, and it is a hotspot for various wildlife.

From the parking area at the end of Hurricane Hill Road, head out onto the wide, paved trail. Along the way, in mid- to late summer, are wildflowers scattered along the route. There's a variety of them and they're colorful, but it's usually difficult to do much else beyond some closeup shots.

At about 1.1 mile come upon a sharp right turn, where Marmots live among the crevices in the rock outcroppings near the trail.

Olympic Marmot Posing for a Photo 200mm f/8 1/250s ISO100

Zigzag a bit up the path, and make the last stretch to a teardrop-shaped loop. This is the end of the paved route.

To your right you will see an information board about 250 feet away. This is a great spot to look upon the Olympic Mountains to the south.

To your left is a short, uphill climb to the summit. Atop the rocks here, find a slab of concrete marked "Hurricane Hill Lookout" and a US Geological Survey marker (seen at right).

Now that you're acclimated to the area near the top, let's explore some options at your disposal... The information board and lookout (to the right of the teardrop) is great for sunrise and also for last light on the mountains during sunset. Along the paved incline, just downhill from the teardrop and summit, is a another good spot – this one for the setting sun over the west horizon.

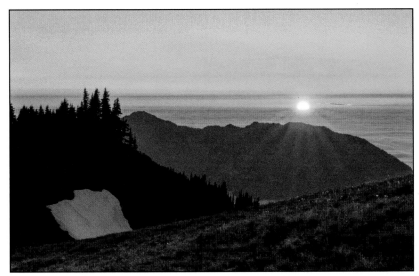

Setting Sun over a Blanketed Strait of Juan de Fuca 100mm f/22 1/30s ISO100

If hiking back down after sunset, keep your camera accessible, as the sky will continue to provide bold colors to capture.

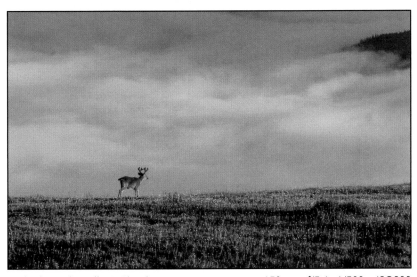

High Above the Valley's Clouds 150mm f/5.6 1/500s ISO200

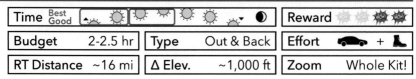

Time	Best Good		Reward
Budget	2-2.5 hr	Type Out & Back	Effort
RT Distance ~16 mi		Δ Elev. ~1,000 ft	Zoom Whole Kit!

I like Obstruction Point Road for two reasons – sweeping panoramas of the Olympic Mountains (I think better than from Hurricane Ridge) and wildflowers. The road begins at the east end of Hurricane Ridge and ends at a parking area just below Obstruction Peak after ~7.8 miles. Though it initially descends, over it's length it gains nearly 1,000 feet of elevation and is entirely unpaved. Check the Olympic National Park website for road conditions.

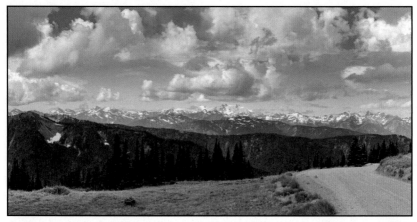

Obstruction Point Road Panorama 55mm f/11 1/320s ISO100 (stitched pano.)

There's really not a lot more to say... I will admit that the somewhat bland driving experience at the beginning is not indicative of the rest of the drive. It gets better quickly and remains interesting throughout.

An Avalanche of Avalanche Lillies 20mm f/8 1/60s ISO200

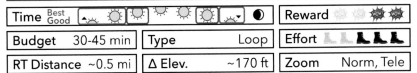

Time Best Good	☀ ☀ ☀ ☀ ☀ ☽	Reward ✦ ✦ 💥 💥
Budget 30-45 min	Type Loop	Effort ◣ ◣ ◣ ◣ ◣
RT Distance ~0.5 mi	Δ Elev. ~170 ft	Zoom Norm, Tele

I would venture to say that Blue Mountain is among the least-visited "drive-to" sites in Olympic National Park. I was initially drawn to check it out during an overnight stay in Port Angeles, as I was looking for a new place to go and enjoy a dinner outdoors, followed by enjoying the light of the setting sun afterwards. It was *just right* for this activity.

Deer Park Road is open seasonally. Check the Olympic National Park website for current conditions. It is on the east side of Port Angeles, about 5 miles from the downtown area. The turnoff is just after the curious, large s-bend along Highway 101 as it makes its way over Morse Creek. A brown sign points the way to the Deer Park Area. (Deer Park is the greater area, including a campground, under National Park Service administration, whereas Blue Mountain is the name of the peak above Deer Park with the trail we will be exploring.)

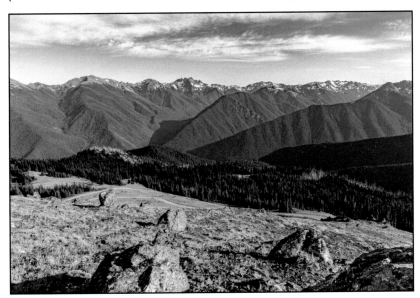

Peering Upon the Olympic Wilderness 24mm f/16 1/160s ISO200

The road is ~18 miles long from the turnoff from Highway 101 to the parking area for the Rainshadow Loop Trail, serving Blue Mountain. Over this distance the road ascends ~5,600 feet! The first ~9 miles is paved until reaching the national park boundary; then it turns to gravel. This gravel road is narrow, steep, and with many curves. I have

driven on it when it has been surprisingly smooth, and I have also experienced it while *expectedly* bumpy. I find ascending it straightforward, but descending it requires **low gear** in your vehicle so as not to burn up your brakes. Please take your time, both ways.

Thriving Succulents at 6,000 Feet 80mm f/4 1/250s ISO1600

At the Deer Park Campground stay left to ascend the final ~0.9 mile to a parking area. This parking area offers sweeping views and is a great place for a tailgate or lawn chair dinner. Once ready, find the Rainshadow Loop Trail. I recommend to walk it counterclockwise, first heading south to upon the ridge that provides a view down onto the road you just ascended.

Olympic Clouds 100mm f/4 1/250s ISO200

East

Quilcene to Staircase

Pacific Rhododendron and Fir 100mm f/5.6 1/40s ISO800

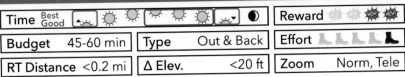

Time	Best Good								Reward				
Budget	45-60 min		**Type**		Out & Back				**Effort**				
RT Distance	<0.2 mi		**Δ Elev.**		<20 ft				**Zoom**		Norm, Tele		

Mt. Walker serves up sensational views for two groups of people – those who want to hike the 2.5+ miles to the top (~2,200 ft elevation gain) and those who prefer to drive up. I fit squarely in the latter, desiring to spend the conserved effort elsewhere on the peninsula. The table at the top covers the "drive to the top" hiking option.

There are two viewpoints at the top – one to the south and one to the north, though the "north" viewpoint is angled more *westerly* than due north. From the south viewpoint on a clear day Mount Rainier presents itself. (A telephoto lens will be required to help better fill the frame, if desired.) Seattle is visible, but some careful studying of the horizon may be necessary to pinpoint its skyline. From the north viewpoint, interesting views of the Quilcene area are enjoyed, as well as Olympic Mountains to the west and Mount Baker in the *more distant* northeast.

The caveat: If distant viewing is desired (as it should be!), then do not bother ascending Mt. Walker unless visibility is good. Otherwise you may only be looking upon clouds or from within one. *I have done so.*

The turnoff from Highway 101 is well-marked, though since it is a somewhat steep, gravel road it is closed seasonally due to mud and/or snow. Directions to each end are also well-marked once at the top, and a short trail leads you to the relative viewpoint.

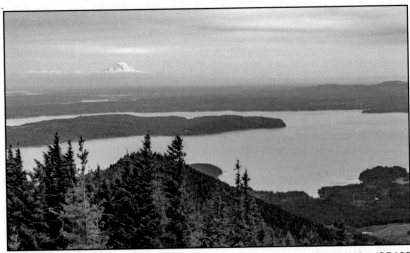

Mt. Walker South Viewpoint 50mm f/8 1/640s ISO100

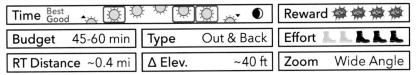

Time	Best Good		Reward ✹✹✹✹		
Budget	45-60 min	Type	Out & Back	Effort 🔺🔺🔺🔺🔺	
RT Distance	~0.4 mi	Δ Elev.	~40 ft	Zoom	Wide Angle

Rocky Brook Falls is my favorite waterfall on the Olympic Peninsula. My family and I first learned about it while camping at Dosewallips State Park one August. It was a hot summer day, and when we got there we were delighted to find other families also enjoying the abundant, chilly mist coming from it. Kids find it especially fun to wade in the cool water, but caution is in order – the water to the right of the falls is deep in places and **the area surrounding the falls is extremely slippery**.

On the north side of Brinnon, turn west onto Dosewallips Road and follow its hilly course for ~2.9 miles to a small parking area on the left. Opposite the parking area is a blue gate with an abundance of signs at a glance suggesting that no one is welcome to enter. My interpretation of the signs is that to each side of Rocky Brook (creek) and the trail serving its falls is private property... Do not wander to the opposite side of the creek or to the left of the trail, so as to maintain "in bounds."

The trail to the waterfall is only about 800 feet long. If visiting during the fall the creek is lined with Vine Maple – they can become quite colorful as their leaves change colors.

Once at the falls, for the best composition, there is a barrier of large rocks to navigate in order to get up close to the water. Before proceeding, I should note – as mentioned above, the waterfall produces abundant mist. While, depending on the season, you might not mind getting your clothes a little wet, your camera gear may not bode as well. Similar to Sol Duc Falls (23), if your gear is not water resistant, you will need to protect it so that it isn't damaged. I usually use either a polarizing or ND filter (or both) here and am regularly wiping it dry for a clean image capture. Lastly, also as noted above, the rocks are wet and extremely slippery. Wear appropriate footwear for good grip.

Back to the approach, with the creek flow to your right, find a route to the left, up and over rocks. This is usually the most straightforward area to access the bottom of the falls (and it is the least impacted by mist). Once on the other side, make your way to the right for the desired composition. Though the further you go right, the more cumbersome the mist will become.

Be mindful of the time of day to visit... When outside the "Good" and "Best" recommendations, the sky is just too bright to work under.

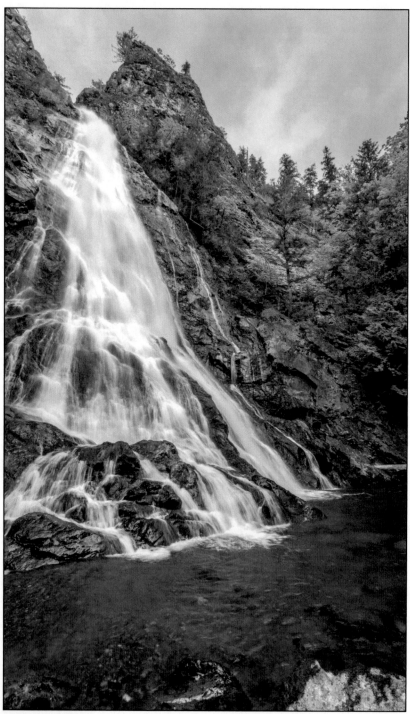

Rocky Brook Falls

17mm f/16 1/10s ISO100

Time	Best Good									Reward			
Budget	30-60 min		**Type**		Out & Back		**Effort**						
RT Distance <0.7 mi			Δ **Elev.**		<20 ft		**Zoom**		Norm, Tele				

> Use the **Pleasant Harbor** tide station for planning.

I thought it prudent to include a few stops along the Hood Canal, because if you'll be visiting Staircase (40) you'll be driving along it and potentially looking for additional stops. Once I started to seek options along the way I was a bit surprised to learn how much of the Hood Canal is lined with private properties. This made the work a little more challenging than anticipated! Thankfully we have the Dosewallips Tidal Area – a "no-brainer" for great landscape photography, and certainly deserving of a stop, really no matter the tide conditions. (Though lower tide is, of course, always better!)

On the south side of Brinnon just north of the Dosewallips River is an unmarked road on the east side of the road... At the road is a brown Dosewallips State Park sign for southbound Highway 101 pointing left for beach access with a blue "Heli-Pad" sign. This is the turn. If you're northbound, you'll only see the backside of this sign but do at least have a blue "Heli-Pad" sign still pointing the way. Follow the short road to the end. A Washington State Park's "Discover Pass" is required for parking. (Annual and one-day passes are available online.)

The trail to the tidal area begins under the trees. After ~0.1 mile emerge and find in sight an observation deck with stairs providing an elevated view about 18 feet high. Once having checked it out, make your way towards the water, as far as the tide will allow. This area has some scattered-about driftwood, shellfish along the beach, and birds galore. There's a lot to see here for such a straightforward outing!

Walking to Harvest 24mm f/11 1/200s ISO200

Just north of Hamma Hamma along the west shore of the Hood Canal is a cluster of posts in the water. Every time I have driven by I have thought to myself that surely a photo is in there somewhere, but on each passing the lighting characteristics just weren't agreeable.

I think on probably my 3rd time by them I thought, "maybe I can make of it what I want, no matter the conditions." My concept was to simulate a "blue hour" look (that time after sunset where the sky turns a radiant blue) by adjusting my camera's white balance down to ~3000 Kelvin.

So one day I pulled off of the highway to give it a shot. I was really going to make something of it... It was about 11:30am on a *very bright day* with completely lackluster clouds. The most damning conditions for any sort of shot, but I figured I'd give the concept a try anyway.

From near the roadside I mounted my camera atop my tripod and attached a 10-stop ND filter to the lens in order to rather excessively smooth the rough water. I manually adjusted the white balance and programmed a 15 second exposure at f/8. To my delight, the result was more or less as expected!

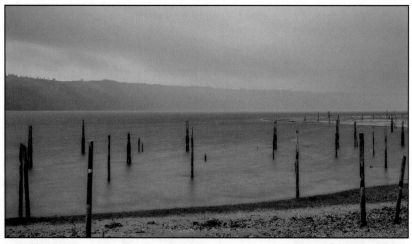

Faux Bleu 50mm f/8 15s ISO200

If traveling southbound along Highway 101, the posts are just after the 321-mile marker. You will need to find a place to safely turn around so that you're heading northbound. Spot the double gate, and a wide shoulder on the right to park along. ...If northbound, the posts are about 0.5 mile north of the Hama Hama Fire District 17 building, alongside Highway 101 in Hamma Hamma (sic).

Time Best Good	☀ ☀ ☀ ☀ ☀ ◑	Reward ✸ ✸ ✸ ✸
Budget 1.5-2.5 hr	**Type** Loop	**Effort** ⚲ ⚲ ⚲ ⚲ ⚲
RT Distance ~2.0 mi	**Δ Elev.** ~200 ft	**Zoom** Whole Kit!

With each of my books, by the time we get to the final sites they're typically more off the beaten path. Staircase is no exception. But let me be clear – if you can arrange your itinerary so that you can include a visit to Staircase, you will be elated that you did.

Like many other districts within the national park, Staircase is a hub to many trails – the majority though being long, overnight-type excursions. The one trail of most interest to us is the Staircase Rapids Loop. There is another trail that I will address at the end, the Shady Lane Trail, providing good accompaniment to the Rapids Loop.

Staircase is accessed from Highway 101 at Hoodsport via State Route 119, eventually turning into Forest Service Road 24. The drive is about 16 miles long, and at ~10 miles the road changes from asphalt to gravel. Unfortunately, this is one of the more bumpy gravel roads in this book... But what a delight – once you come to the national park boundary (~14.5 miles) the road changes back to asphalt!

While Staircase is often overlooked by out-of-state visitors, it seems to be a popular destination for Washington residents... This is generally only an issue on summer weekends, so as noted in a few prior sites if your itinerary demands a summer weekend visit, try to arrive early or late in the day to ensure parking availability.

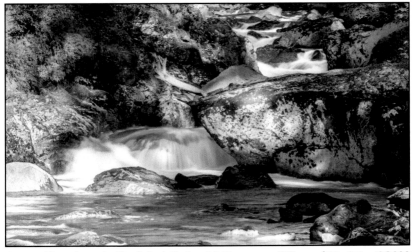

Autumn Flow along the North Fork Skokomish River 250mm f/11 0.5s ISO200

The Staircase Rapids Loop Trail begins across the large bridge spanning the North Fork Skokomish River. Cross it and find an information board with a great map, but at time of writing the "Your Are Here" depicts your location on the opposite side of the river. Whoops. Stay straight, heading into the forest. In short order find a sign pointing to a "Big Cedar." It is a downed tree (and not entirely photogenic) but only requires a 5 minute round trip to explore.

The trail is so enjoyable, with a few views of the river along the way.

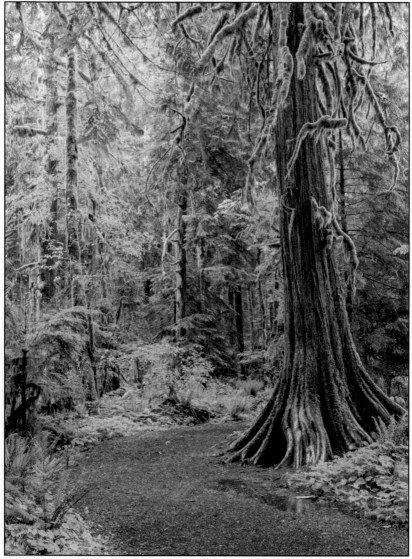

Along the Staircase Rapids Loop Trail 35mm f/8 1/25s ISO800

Be on a keen lookout for mushrooms. There are many here, especially in the fall. While on the topic of seasons, the river's flow will be most extreme in the spring and early summer as snowpack melts. It will calm in the fall. Colors, as expected, are vivid green in late spring but dull a bit come summer. Fall boasts nice shades of yellow and orange.

100mm f/11 8s ISO200

After ~0.9 mile reach a rocky intersection; veer right in order to cross the river. After walking alongside some huge boulders the bridge comes into view. I have spent abundant time at this bridge, taking a variety of photos with it in the composition. Photos from on the bridge of the river and its adjacent trees are superb.

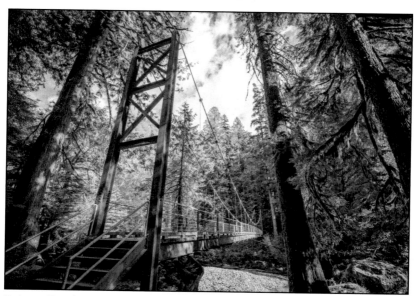

Staircase Rapids Loop Suspension Bridge 15mm f/8 1/10s ISO100

Once on the other side, turn right to head back in the direction of the ranger station.

Notice how this side's character is different than the other's. At ~1.4 miles it even boasts its own mini "Hall of Mosses" with towering Bigleaf Maples and Western Red Cedars covered in moss. A small stream lays just beyond this area, but a larger, more photogenic creek is just ahead. Find access to it just off the trail to the left, down some rocks.

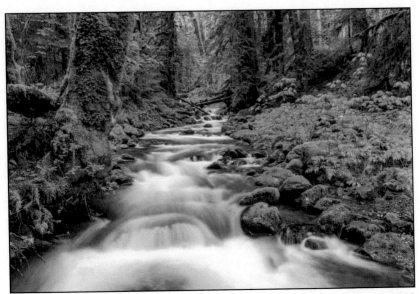

Slate Creek

28mm f/16 2s ISO50

A footbridge crosses this creek just ahead. (It is easy to veer off-trail ahead of the bridge and miss it.)

The trail rallies to its end with a bit of a climb before its final descent to the parking area behind the ranger station.

If you have a bit of time left, I do recommend crossing the large bridge again, turning left, and exploring the first section of the Shady Lane Trail. It skirts the river and provides some unique, wider compositions not seen along the Staircase Rapids Loop Trail. A foot bridge is at ~0.1 mile, followed by an indentation in the rock (dare I call it a "cave," as it is rather shallow). Another bridge comes <0.1 mile, and where I usually like to turn around.

If time permits, check out Lake Cushman at pullouts along the drive back.

35mm f/8 0.3s ISO100

Appendix - Select Elevation Profiles

For three sites within this book, the "Δ Elev" doesn't sufficiently represent the route's grade. The following elevation profiles better complete the story on for these three:

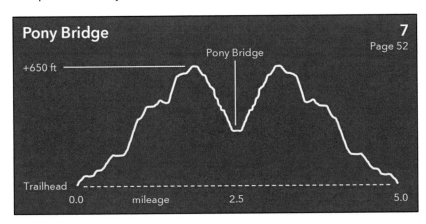

Pony Bridge — 7 — Page 52

Pony Bridge

+650 ft

Trailhead

0.0 mileage 2.5 5.0

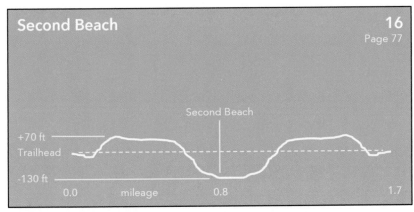

Second Beach — 16 — Page 77

Second Beach

+70 ft
Trailhead

-130 ft

0.0 mileage 0.8 1.7

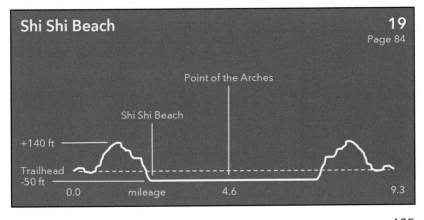

Shi Shi Beach — 19 — Page 84

Point of the Arches

Shi Shi Beach

+140 ft

Trailhead
-50 ft

0.0 mileage 4.6 9.3

No.	Page	Site	Time	
			Best	Good
1	38	Rain Forest Nature Trail	-AM thru AM+ & PM+	MID thru -PM
2	41	Lake Quinault Lodge	PM+ thru NT	MID thru -PM
3	42	Gatton Creek Falls	-PM thru PM+	AM+ thru MID
4	43	Other Quinault South Shore Options...		
5	48	Merriman Falls	-AM thru AM+ & -PM	MID & PM+
6	50	Bunch Falls	AM+ & -PM	-AM & PM+
7	52	Pony Bridge	-AM thru AM+	MID thru -PM
8	54	Kestner Hm. & Maple Glade	-AM & PM+	AM+ & -PM
9	57	Queets River View	MID thru -PM	AM+ & PM+
10	60	Tree of Life	MID thru -PM	AM+ & PM+
11	61	Beach 4	AM+ & SS	-AM & MID & PM+
12	64	Ruby Beach	AM+ & SS	-AM & MID & PM+
13	66	Taft Pond	-AM & PM+	AM+ thru -PM
14	68	Hall of Mosses	PM+ thru SS	SR thru -AM
15	73	Other Hoh Options...		
16	77	Second Beach	AM+ & SS	-AM & MID & PM+
17	78	James Pond	-AM	AM+ thru PM+
18	80	Rialto Beach	SR thru AM+ & SS	MID & PM+
19	84	Shi Shi Beach	AM+ & SS	-AM & MID & PM+
20	87	Cape Flattery	AM+ & SS	-AM & MID & PM+
21	90	Salmon Cascades	MID	AM+ & -PM
22	92	Ancient Groves Nature Trail	PM+	AM+ & -PM
23	93	Sol Duc Falls	-AM & PM+	AM+ thru -PM
24	96	Fairholme	SR & -PM thru PM+	AM+ thru MID
25	98	Lake Crescent Lodge & Vic.	-AM thru AM+ & SS	SR & MID
26	99	Marymere Falls	-AM & -PM thru PM+	AM+ thru MID
27	102	Mount Storm King	AM+ thru MID & SS	-PM
28	104	Spruce Railroad Trail	AM+ thru -PM	-AM
29	106	Madison Falls	AM+ & -PM	MID & PM+
30	108	Glines Canyon Dam Overlook	MID	AM+ & -PM
31	112	Tongue Point	AM+ thru -PM	-AM & PM+
32	114	Nighttime Car Light Trails	Nighttime	-
33	117	Hurricane Ridge & Sunrise Pt.	SR & PM+ thru SS	-AM thru -PM
34	120	Hurricane Hill	SR & SS	MID thru PM+
35	122	Obstruction Point Road	SR thru -AM	AM+ thru MID
36	123	Blue Mountain	SR thru -AM & SS	AM+ & PM+
37	126	Mt. Walker	SR & SS	MID thru PM+
38	127	Rocky Brook Falls	PM+	-AM & -PM
39	129	Dosewallips Tidal Area	PM+	-AM & MID thru -PM
40	131	Staircase	-AM & MID & PM+	AM+ & -PM

Reward (Wow's)	Budget	Type	Effort (Boots)	RT Distance	Δ Elevation	Zoom
2	1.5-2 hr	Loop	2	~0.9 mi	~90 ft	Norm, Tele
1	15-45 min	Meandering	0	<0.2 mi	<30 ft	Wide Angle
1	30-45 min	Out & Back	1	~0.6 mi	~10 ft	Normal
(Varies)						
3	15-30 min	Out & Back	2	<300 ft	~20 ft	Normal
2	30-45 min	Out & Back	2	<300 ft	~20 ft	Norm, Tele
3	3.5-4.5 hr	Out & Back	4	~5.0 mi	See pg. 135	Norm, Tele
4	1-2 hr	Loop	2	~1.5 mi	~30 ft	Wide, Norm
2	15-30 min	Roadside	0	<300 ft	<10 ft	Telephoto
4	30 min	Out & Back	2	~600 ft	~20 ft	Normal
3	1.5-2 hr	Out & Back	3	~0.9 mi	~100 ft	Norm, Tele
4	1-1.5 hr	Out & Back	2	~0.7 mi	~70 ft	Norm, Tele
3	15-30 min	Roadside	0	<500 ft	<10 ft	Telephoto
4	1-2 hr	Lollipop Loop	2	~1.0 mi	~90 ft	Whole Kit!
(Varies)						
3	1.5-2 hr	Out & Back	3	~1.7 mi	See pg. 135	Norm, Tele
1	45-60 min	Lollipop Loop	1	~0.4 mi	<10 ft	Norm, Tele
4	3-4 hr	Out & Back	4	~3.5 mi	~40 ft	Norm, Tele
4	5-6 hr	Out & Back	5	~9.3 mi	See pg. 135	Norm, Tele
4	1-2 hr	Out & Back	3	~1.4 mi	~280 ft	Norm, Tele
3	30-45 min	Out & Back	2	~0.1 mi	<30 ft	Norm, Tele
2	45-60 min	Lollipop Loop	2	~0.5 mi	~60 ft	Normal
4	1-2 hr	Out & Back	3	~1.6 mi	~200 ft	Wide, Norm
1	15-45 min	Varies	1	<500 ft	<30 ft	Wide, Norm
2	30-90 min	Varies	1	<1.0 mi	<20 ft	Whole Kit!
3	1-1.5 hr	Lollipop Loop	3	~1.8 mi	~400 ft	Normal
4	3.5-4.5 hr	Out & Back	5	~4.2 mi	~2,000 ft	Wide Angle
3	1.5-2 hr	Lollipop Loop	3	~2.4 mi	~80 ft	Wide, Norm
2	15-30 min	Out & Back	2	~0.2 mi	~20 ft	Normal
3	4.5-5.5 hr	Out & Back	5	~7.4 mi	~900 ft	Normal
4	1-2 hr	Out & Back	4	<0.7 mi	<30 ft	Norm, Tele
3	30-45 min	Roadside	0	<200 ft	<10 ft	Wide Angle
4	1-3 hr	Varies	2	<1.5 mi	<300 ft	Norm, Tele
4	2-3 hr	Out & Back	4	~3.2 mi	~740 ft	Norm, Tele
2	2-2.5 hr	Out & Back	2WD + 1	~16 mi	~1,000 ft	Whole Kit!
2	30-45 min	Loop	3	~0.5 mi	~170 ft	Norm, Tele
2	45-60 min	Out & Back	1	<0.2 mi	<20 ft	Norm, Tele
4	45-60 min	Out & Back	3	~0.4 mi	~40 ft	Wide Angle
2	30-60 min	Out & Back	1	<0.7 mi	<20 ft	Norm, Tele
4	1.5-2.5 hr	Loop	3	~2.0 mi	~200 ft	Whole Kit!

About the Author

Anthony Jones, who friends and family call "AJ," lives in the Seattle, Washington area with his wife and their two daughters.

In April 2011 he visited Joshua Tree National Park, laying the foundation for what would become regular photography pilgrimages to many other U.S. National Parks.

AJ enjoys the planning and logistics aspect of a trip as much as the trip itself, and in so he realized a shortage of available books focused on the photographer's specific needs while visiting national parks. Thus, his idea to write a series of these types of books was born...